MODERN ART AT THE
PINAKOTHEK DER MODERNE

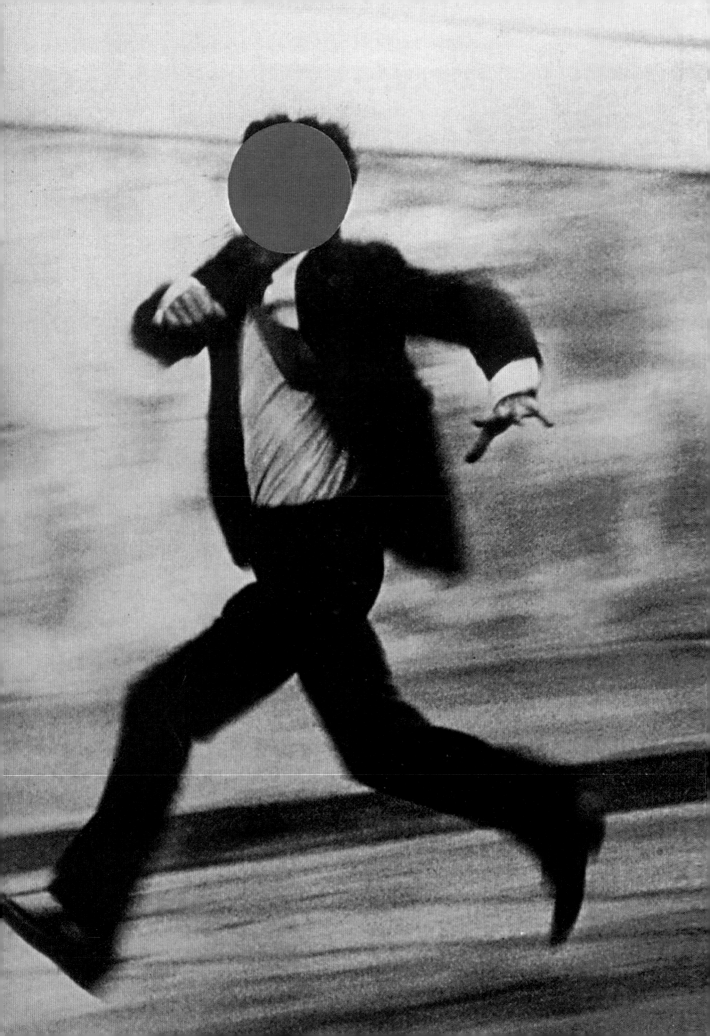

Modern Art at the Pinakothek der Moderne Munich

Cathrin Klingsöhr-Leroy

C.H. BECK / SCALA PUBLISHERS

© 2005 Scala Publishers Ltd, London
and Verlag C.H. Beck oHG, Munich

First published:
Scala Publishers Ltd
Northburgh House
10 Northburgh Street
London EC1V 0AT

In association with:
Verlag Beck oHG
Wilhelmstr. 9
Munich

ISBN 3 406 53188 1 (Beck)
ISBN 1 85759 333 2 (Scala)

Editorial: Verlag C.H. Beck, Munich / Scala Publishers
Design: Roger Hammond for Scala Publishers
Translation into English: Jane Bainbridge
Typesetting: Emma Pattison
Proof-reading: Katy Moran, Julie Pickard
Printed and bound in Italy

10 9 8 7 6 5 4 3 2 1

Frontispiece: John Baldessari,
Man Running / Men carrying Box,
1988–1990 (Detail)

Photography: Bayerische Staatsgemäldesammlungen, München,
and Artothek, Weilheim

www.beck.de

www.scalapublishers.com

Copyrights:
Amsterdam, L & M Services (© Robert Delaunay)
Barjac, Anselm Kiefer
Bonn, VG Bild-Kunst 2004 (© Succession Pablo Picasso, Alexej von Jawlensky, Georges Braque, Succession Henri Matisse, Fernand Léger, Gino Severini, Wassily Kandinsky, Karl Schmidt-Rottluff, Oskar Kokoschka, Max Beckmann, Otto Dix, Giorgio de Chirico, Max Ernst, René Magritte, Fondation Gala-Salvador Dalí, Succession Miró, Lyonel Feininger, Paul Klee, László Moholy-Nagy, Marino Marini, The Estate of Francis Bacon, Antonio Saura, Heimrad Prem, Fritz Winter, Wolfgang Otto Schulze, Willi Baumeister, fam.jorn, K. Appel Foundation, Dedalus Foundation, The Willem de Kooning Foundation, Franz Kline, Robert Rauschenberg, Jasper Johns, Fondation Antoni Tàpies Barcelona, Emil Schumacher, Eduardo Chillida, Hermann Nitsch, Blinky Palermo, The George and Helen Segal Foundation, Carl Andre, Richard Serra, Estate of Dan Flavin, Art Judd Foundation – VAGA New York, Robert Morris, John Chamberlain, Stephan Balkenhol, Joseph Beuys, Imi Knoebel, Thomas Demand, Bruce Nauman, Andreas Gursky)
Città di Castello, Collezione Burri
Cologne, Elisabeth Nay-Scheibler
Cologne, Gerhard Richter
Cologne/New York, Galerie Michael Werner (© Markus Lüpertz, Per Kirkeby, Jörg Immendorff, A. R. Penck)
Derneburg, Georg Baselitz
Düsseldorf, Hilla und Bernd Becher
Frankfurt, Ludwig Meidner-Archiv im Jüdischen Museum
Hemmenhofen, Nachlaß Erich Heckel
London, Sam Taylor-Wood
Long Beach, Bill Viola Studio
Much Hadham, Henry Moore Foundation
Munich, Janine Schlemmer
Munich, Rupprecht Geiger
New York, Andy Warhol Foundation for the Visual Arts/ARS
Rome, Jannis Kounellis
Santa Monica, John Baldessari Studio
Seebüll, Nolde-Stiftung
Vancouver, Jeff Wall Studio
Venice, Emilio Vedova
Vienna, Arnulf Rainer
Wichtrach/Bern, Ingeborg & Dr. Wolfgang Henze-Ketterer (© Ernst Ludwig Kirchner)
Wuppertal, Tony Cragg

Contents

6 Foreword

10 The Avant-Garde Movement of the Early Twentieth Century
Fauvism, Cubism, Orphism, Futurism, Der Blaue Reiter, Expressionism

36 The 1920s
Retour à l'ordre, New Realism, Surrealism, Bauhaus

58 The Second World War and the Years that Followed
Picasso, Beckmann, European Post-War Abstractionism, Abstract Expressionism, Tachism, Cobra

82 How the Image was Problematised
during the Last Third of the Twentieth Century
Arte Povera, Pop Art, Fluxus, Minimal Art, Beuys, Baselitz, Capitalist Realism

110 New Media, Photographs and Video

128 Index

Foreword

The Pinakothek der Moderne has been a magnet for visitors since it opened in September 2002. It brings together under one roof four important international collections of architecture, design, graphics and painting, sculpture and the new media. Four institutions with divergent biographies, strategies and profiles here enter the public arena together. They forge new links and establish new perspectives; each maintains its own individuality but at the same time they develop synergies. An essential requirement for this is the open-plan architecture with the diagonal staircase linking all the different areas. The staircase creates connections and surprising cross-references, but at the same time it reflects the specific structure of the development of art in the twentieth century: its course is not linear; rather, equal positions intersect, establishing a kind of dialogue.

The significance of the architecture is conveyed in the large, clear, daylit spaces of the upper floor, more than 5000 square metres in area, which house the contents of the Bavarian state picture collection of twentieth- and twenty-first-century art. Starting with the early avant-garde movements at the beginning of the last century, the collection spans the years right up to the experimental trends of the present day. The contrast between representational groups of works sets up a tense and fascinating discourse about the central questions and innovations of modern and contemporary art. However, the history and biography of this expanding collection, which today counts among the most important of its kind internationally, are deceptively recent: in 1950 only seven, albeit singular, works of art formed the beginning of a collection that in the course of a few

decades – through good fortune, strategic skill and the tireless involvement of many – grew in quantity and quality to considerable dimensions. The first of these seven acquisitions dates back to the legendary Hugo von Tschudi, who already in 1910 had been able to secure for the collection Henri Matisse's *Still-Life with Geraniums*, painted in the same year, direct from the artist's studio. He thus guided the first purchase from the artist via a museum out into the world. Tschudi himself – whose incomparable achievement and exceptional feeling for quality was not recognised, either during his time as director in Berlin, or in Munich – did not live to see this happen again. It was only after his death in 1919, and in the face of much opposition, that his assistant succeeded in giving officially as a gift the picture and a sculpture of the artist, together with the so-called Tschudi donation, which forms a marvellous focal point for the Neue Pinakothek. Franz Marc's *Red Deer* (acquired in 1917), *Venice* by Oskar Kokoschka (acquired in 1925), Lovis Korinth's *Delphinium* and *Landscape with the Walchensee* (acquired in 1924 and 1929, respectively) followed, as well as Max Beckmann's *Self-Portrait* of 1944, acquired in 1949 as the first top-quality purchase after the Second World War. Other German collections had been robbed of their most important examples of modern art by the Nazis, but in Munich no collection of early twentieth-century art worth mentioning had been formed. There was no engagement with new trends – such as 'Der Blaue Reiter': a position that persisted into the 1970s, with the so-called 'cultural struggle' over the acquisition of Beuys's installation *Show Your Wounds* for the Städtische

Erich Heckel
A Clear Day
(Detail from page 26)

Galerie in the Lenbachhaus. Given this background, the exceptional success story of the Pinakothek der Moderne, which introduced to a wide public a paradigmatic change in the appreciation of contemporary art, is all the more amazing. By means of successful individual initiatives by private donors and associations, as well as the strategically clever collecting policy of the museum curators responsible, an internationally exceptional collection of works of art was formed. In this process the principal attention was focused on the Classical Moderns, whose profile quickly developed thanks to spectacular gifts and carefully selected individual acquisitions.

The Sophie and Emanuel Fohn collection constitutes one of the most important bodies of works: it also represents a warning against all totalitarian regimes. This claim is linked to a collection of the most powerful testimonials to the Classical Moderns, which were seized from the German museums in 1937 by the Nazis in the 'Degenerate Art' campaign. The artists Sophie and Emanuel Fohn, who at that time were living in Rome and owned an important collection of works by nineteenth-century German artists, decided on the spur of the moment to champion the endangered works and to give up their own collection in exchange. It is not possible to value highly enough this exemplary deed, which enabled numerous works by modern artists to be rescued from an uncertain fate. No less spectacular is the bequest in 1971 of the artists Woty and Theodor Werner. Their collection is revealing to the artistically trained eye that recognises a timeless quality in the unusual and in the new, whether it be the cautiously reasoned works of Paul Klee or perhaps above all the apparently sterile works of the Cubists.

An important moment came in 1974 with the addition of a body of thirty works by Max Beckmann from the collection of Günter Franke. Enhanced by the Pinakothek's own acquisitions – such as the *Temptation* triptych – this collection is extremely significant in its

representation of Beckmann's works, and is comparable only with the collection in St Louis, the place where he was first active in America. In 1977 major works of the Expressionist artists were added thanks to the Martha and Markus Kruss collection. Since then the works of the Brücke artists have been extremely well represented. In 1976 the assets of the museum were enriched by important twentieth-century paintings from the Klaus Gebhardt collection. Another high point of the still recent history of the collection followed in 1982 with the Theo Wormland collection, with its many-faceted nucleus of Surrealist art.

Thanks to the Prince Franz of Bavaria Foundation and to the active purchasing of the registered association of Munich galleries (now PIN, the Friends of the Pinakothek der Moderne), it was possible to raise the profile of high points in contemporary art through the museum's acquisitions, particularly in the field of German art (Georg Baselitz, Sigmar Polke, Gerhard Richter and Blinky Palermo), as well as recently in the new media, whose profile has been raised through the 'space-invading' installations of, among others, Bruce Nauman, Pipilotti Rist, Bill Viola, Gary Hill and Francis Alys, and many important photographic acquisitions. The huge room installation, *The End of the 20th Century*, by Joseph Beuys is impressive; it is presented in the context of a significant body of other works by this artist. The art of the USA was for a long time represented only by individual works, but the museum has now succeeded in building outwards from its central funds. Thus, within Pop Art, interest is focused consciously on the unique position of its most important protagonist, Andy Warhol, who is represented with a small selection of exemplary works characteristic of his whole oeuvre. The same goes for Dan Flavin and Donald Judd, whose trailblazing artistic achievement is represented in the Pinakothek der Moderne in a way unique in Europe. This brief overview alone characterises a special feature of the collection: its backbone comprises important

bodies of work of exceptional individual types of art, and these have been carefully built upon and are still being expanded. The aim is not to build an encyclopaedic collection of the greatest possible completeness, but to define the specific profile and to concentrate on central, defining artistic questions.

It is not about quantity – that is to say, about an abundance of works to fill wall and floor space – but about quality. Future acquisitions will be made against the background of the other two museums, which set the high standard, but also with a watchful eye for new trends – and not simply those that follow the mainstream of art. A tour of the museum demonstrates this convincingly in clearly structured spaces, lit from above, which give the individual works room to breathe and which provide a truly stimulating interplay between the pictures. The works of the Classical Modernists are installed in a central position for longer-term presentations, but the presentation of the more recent trends is changed more frequently. Here, on the one hand, are the most diverse new media, which require breadth of variation; on the other hand, the frequently outsize formats and the size of the materials used demand a more flexible plan. Optically this finds expression in a bipartite division whose unifying centre is formed by the rotunda: while the north-west exhibition area contains the Classical Moderns, more recent art is displayed in a changing exhibition in the south-eastern wing. The aim of the presentation as a whole is not to provide a chronological tour, with no gaps, through the twentieth century. Instead, fundamental questions stand at the centre and they develop strength in the dialogue of outstanding artists. Thus the significance of often parallel developments in Classical Modernism is often easier to understand by looking at just a few works of art. The changed mechanisms of perception and a new understanding of reality in the second half of the twentieth century are more precisely conveyed by individual works than in a panorama.

Over and above the spectator's view, oriented as it is to traditional categories and forms of presentation, it is also, however, valid to integrate artistic strategies that are generally excluded from museum collections. Thus the Pinakothek der Moderne envisages itself as an active forum for dialogue. It is just as much a place of meditative peace and concentration as a vital field of experimentation, and it participates actively in the artistic discussions of the present day. In the Alte and the Neue Pinakothek, and also the Glyptothek, the collection of antiquities and the Städtische Galerie, Munich's artistic arena thus has at its disposal an incomparable cultural fund, which in its unique density and abundance invites the visitor to creative discussion and contemplative perception.

Carla Schulz-Hoffmann

The Avant-Garde Movement of the Early Twentieth Century

Fauvism, Cubism, Orphism, Futurism, Der Blaue Reiter, Expressionism

The art of the early twentieth century was influenced by a multitude of new departures. The desire for authenticity was born of a need for renewal and change and directed against long-standing traditions. Artists questioned and abandoned the very fundamentals of conventions. This impression is not revealed by historical analysis alone; it is apparent in the paintings themselves: their freshness, their unconventionality, and their glory in the use of colour still convey to the spectator today the great intensity of the spirit of upheaval and awakening of this generation of artists.

This is particularly the case for the paintings of the 'Brücke' ['Bridge'] Expressionists, whose works are extremely well represented in the Pinakothek der Moderne. Ernst Ludwig Kirchner was both a protagonist and a founder of the Brücke movement in 1905; he defined spontaneity and originality as the main concerns of a 'new' form of painting and his paintings on display in the Pinakothek illustrate his oeuvre from the Brücke period until his death: *Naked People at Play*, *Circus*, *Elisabethufer*, and *Self-Portrait as an Invalid* embrace the high points of his work. The emotion and directness of his brush strokes, the fresh colours, rich in contrasts, of his early work, and his striving for abstraction and calm during the late 1920s and 1930s can all be appreciated in the examples to be seen here.

Along with Ernst Ludwig Kirchner it was especially Erich Heckel, Karl Schmidt-Rottluff, Emil Nolde and Otto Müller who were closely allied artistically with the Brücke movement. Common to them all and characteristic of their work is a striving for originality, for an unbroken, fresh colourfulness and for the intense visualisation of human emotions; in this respect Emil Nolde's intensity of expression and Otto Müller's artistic language, always gently stylised and with a lyrical tendency, occupy a particularly special position.

Fernand Léger,
Landscape No. 2
(Detail from page 18)

Oskar Kokoschka and Lovis Corinth stand out as completely distinct artistic personalities, who, although not directly related to the artists of the Brücke movement, nevertheless pursue in their work an expressionist approach while translating their emotional experiences into a specific art form – Kokoschka's *The Emigrants* and Corinth's *Thomas and Wilhelmine* should be viewed as examples of this.

One of the sources of Brücke Expressionism lies in the painting of the French Fauves. Their influence can be seen most clearly in Erich Heckel's painting *Girl Lying Down* of 1909. The intensity and warmth of the colours characterises Heckel's work just as it does the work of the Fauves, and its shimmering brightness can be interpreted as the expression of an uninhibited joy for living. The point of departure for the reception of the Fauves was their first exhibition in Germany, held at the Cassirer Gallery in Berlin. Along with an early work by Georges Braque, *Bay at La Ciotat*, of 1907, this aspect of the collection is represented by Henri Matisse's important work *Still-Life with Geraniums*. This painting, at once strongly constructed and imbued with a cheerful sensuality, makes clear that, for the French artists, spontaneity and vivacity were not their foremost concerns, as they were for the painters of the Brücke movement; rather, immense importance was attached to the concept of a balanced, harmonious composition and beautiful, decorative lines.

The interest in space and volume, in construction and analytical perception, which may be counted as characteristic of the French school of painting, became one of the foundations of Cubism, a movement whose importance for twentieth-century art cannot be overstated. The meeting between Georges Braque and Pablo Picasso in Paris in 1907 spawned a unique process of creation and invention to which both artists contributed in equal measure. Both painters, whose studios in Montmartre were not far apart, developed through a continuous exchange of ideas a form of art

that rejected all the conventions of spatial representation. In place of the one-dimensional, fixed viewpoint, which for centuries had been the basis of the central perspective composition of European painting, Braque and Picasso shifted the viewpoint into multiple dimensions, which led to the deconstruction of the objects represented on the canvas. For example, in Braque's painting *Woman with a Mandolin* of 1910, an example of early Cubism in the collection of the Pinakothek der Moderne, it is not only the disintegration of the object of the painting that is evident; the oval format and the limitation of colour to the 'non-colours' of grey, beige and black are also characteristic. In the next phase of the movement – the synthetic Cubism of 1912 to 1914 – Braque and Picasso reintegrated colour into their art. They had initially abandoned the illusionary representation of reality, but this too now returned to their work with the employment of pieces of paper, musical scores or labels, which were stuck on to the canvas or depicted in a *trompe-l'oeil* effect. Juan Gris was a particular exponent of this facet of Cubism; his *Bottle of Bordeaux* (1915) makes colour and illusionary substance the central elements of its subject matter.

However, the Cubism of Braque and Picasso was for many artists the point of departure for a very individual interpretation. Futurism is represented in this collection by Boccioni's *Volumi orizzontali*, a portrait of the artist's mother painted in 1912; to some extent this new impetus developed the possibilities of representing movement by means of a continuation of the Cubists' analysis of shape. Fernand Léger, on the other hand, transformed the achievements of Cubism into so-called 'Tubisme'. He uses only primary colours in his paintings and he limits himself to an extremely reduced vocabulary of shapes. In Léger's *Landscape No. 2* (1913) a town emerges as if out of a box of toy building bricks, with the help of tubes, pyramids and rectangular stone blocks. Robert Delaunay developed

colour in his style of painting, going forward from Cubism, but also returning to the ideas of the Neo-Impressionists Seurat and Signac to achieve the effects of his 'Orphism'. He wanted the clear colours of the palette he used for his paintings to convey, with the help of simultaneous contrast, the luminosity of the light and ultimately the very experience of vision. If Delaunay's work of 1913, *The Cardiff Team* – an anthem to modern life – can be seen as embodying the symbols of that life – sport, city, technology – then his art may be said to incline towards abstraction, ultimately divorcing itself from its 'subject'.

Wassily Kandinsky and Franz Marc, the two editors of the *Der Blaue Reiter* [The Blue Rider], an almanac that had appeared in Munich in 1912, followed a different intellectual path towards abstraction. For them, too, colour was the essential element of painting. Thus, with his *Rider on the Bridge* (1909), Kandinksy created a painting that, by means of the independence of its colour – which is detached from its object – conveys a dreamy, almost musical impression. Kandinsky wanted to paint 'spiritual' pictures. For him, the artist's work should spring from his inner vision and thus, as in the case of his *Dreamy Improvisation* (1913), should no longer retain any of the original reality of the picture's subject. While August Macke remained committed to the light and colour of Delaunay's painting with his important work *Girls under Trees* (1914), Franz Marc, like Kandinsky, sought to express an inner vision through his paintings: the clear, solid structure that is characteristic of works such as *The Mandrill* (1913), mirrors a cosmic dimension, an eternal, uninterrupted beating of Nature's pulse, which is ultimately expressed in a completely abstract manner in his *Fighting Forms* of 1914.

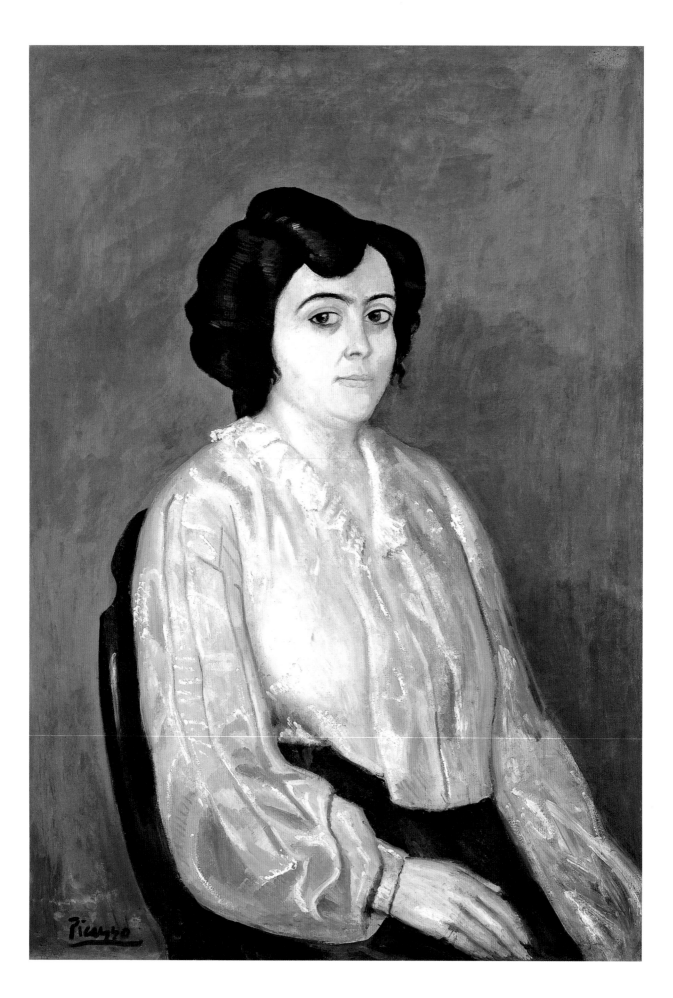

Pablo Picasso
Malaga 1881 – Mougins 1973

Madame Soler, 1903
Oil on canvas, 100 x 73 cm
(Inventory no. 13672)
Acquired 1964

The portrait of Madame Soler
belongs to Picasso's 'Blue
Period' (1901-1904), a time
when the artist was in Paris and
turned for his subjects to the
poor and the rejected, to those
who inhabited the fringes of
society. The deep melancholy of
these works was emphasised by
the graduated blues of the
palette to which Picasso
confined himself. Madame
Soler, one of the few bourgeois
subjects of this period of
Picasso's art, was the wife of
Picasso's tailor in Barcelona,
who supported the young artist.

Alexei von Jawlensky
Torzhok, Russia 1864 –
Wiesbaden 1941

*Woman in a Landscape near
Carantec,* 1905–06
Oil on board, 52.8 x 49.2 cm
(Inventory no. 13463)
Gift of Sofie and Emanuel
Fohn, 1964

It was not only his engagement
with the works of van Gogh
and Fauvism but also his
meeting in Munich with Wassily
Kandinsky and Gabriele Münter
(later to become members of
Der Blaue Reiter) that
encouraged Jawlensky in his
search for a new meaning for
colour in painting, for a form of
expression that went beyond the
simple depiction of reality. Thus
the Breton landscape near
Carantec does not reflect the
actual colours of nature; rather it
depicts a spiritual picture which

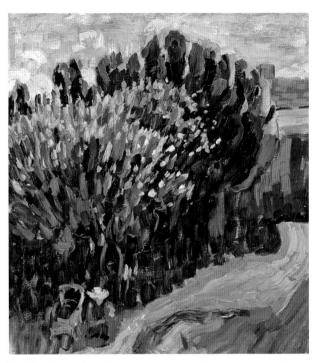

'translates into colour the
[artist's] passionate soul'.

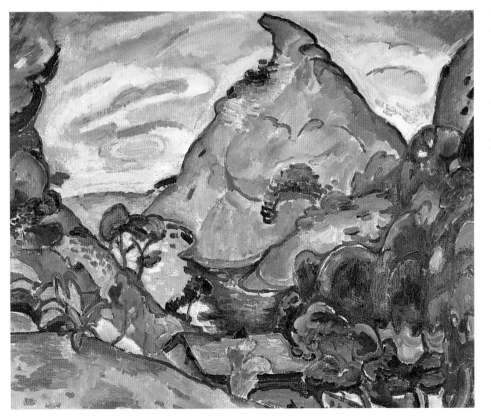

Georges Braque
Argenteuil 1882 – Paris 1963

Bay at La Ciotat, 1907
Oil on canvas, 60 x 73 cm
(Inventory no. 13426)
Acquired 1964

Before he and Picasso turned to
their common study of the
analysis of shape, which was to
lead both artists towards
Cubism, Braque went through a
Fauvist period during which he
interpreted his canvas as a
surface to be structured with
colour. His *Bay at La Ciotat,*
which the artist painted several
times in different lights, is seen
here under a grey sky, depicted
using a combination of grey,
violet, pink, white and dark
green, which lies like a pall over
the southern landscape.

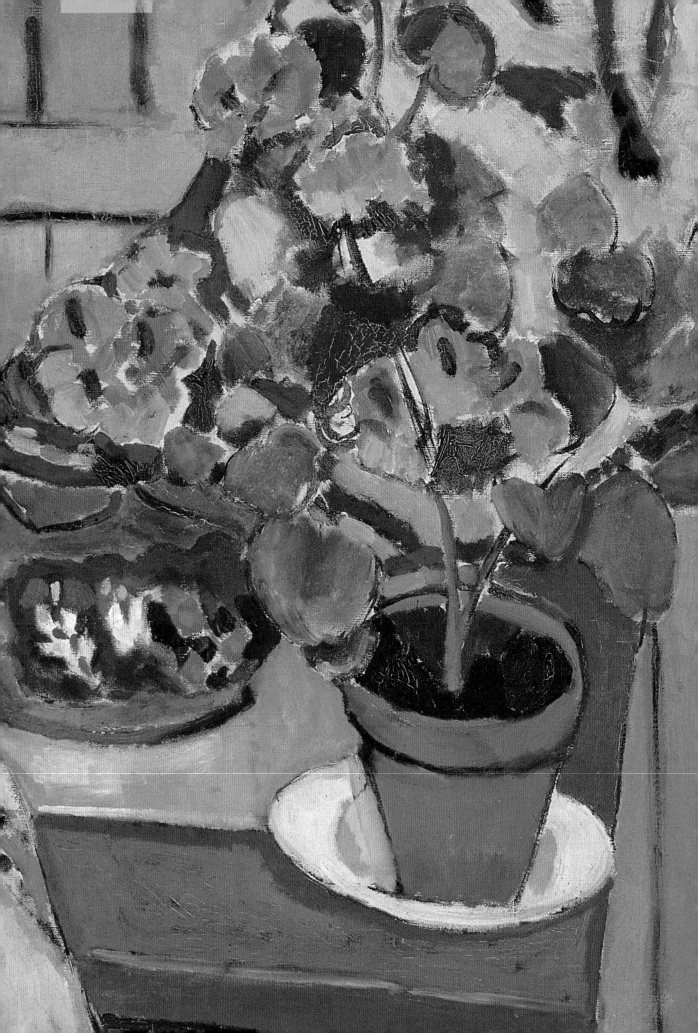

Henri Matisse
Le Cateau-Cambrésis 1869 –
Cimiez, near Nice 1954

Still-Life with Geraniums, 1910
Oil on canvas, 93 x 115 cm
(Inventory no. 8669)
Acquired 1912 as part of the
Tschudi donation, the gift of
Marcus Kappel

The painting belongs to a group
of important still-lifes executed
circa 1910. The dominance of
colour, the significance of the
ornamental, the pictures within
the picture – a Fauvist landscape
and a drawing of a nude figure
– lend the composition a
programmatic character. It
confronts reality with the world
of art – a world with its own
laws, a world of harmony, purity
and peace. The subject retreats
behind the balanced interplay of
the artistic medium.

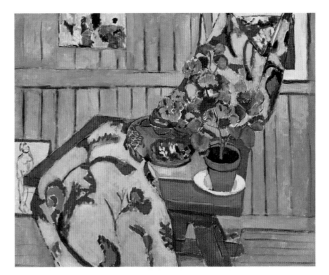

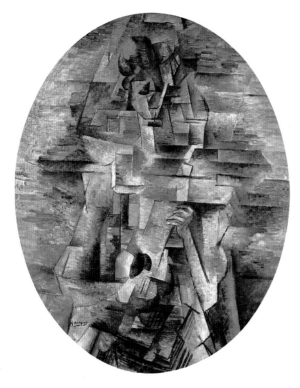

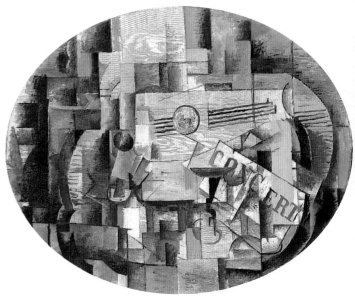

Georges Braque
Argenteuil 1882 – Paris 1963

Woman with a Mandolin, 1910
Oil on canvas, 91.5 x 72.5 cm
(Inventory no. 13824)
Acquired 1967

Woman with a Mandolin is a
work characteristic of analytical
Cubism. The oval format already
rejects the historical form of
perspective, which is calculated
from each of the four corners of
a painting and which represents
the traditional, actual, spatial
relationships. In contrast, the
Cubists – particularly Braque
and Picasso – dissolve the
illusion of space in favour of
multiple viewpoints, which leads
to the deconstruction of the
subject that we see represented.
Different viewpoints and a
series of different time frames
are presented together in one
image, so that there is little that
is immediately recognisable in
the likeness.

Georges Braque
Argenteuil 1882 – Paris 1963

The Guitar, undated
Oil on canvas, 65 x 81 cm (oval)
(Inventory no. 1719)
On loan from a private
collection since 1978

During the period of synthetic
Cubism, which lasted from
about 1912 until 1914, Braque
and Picasso used a collage
technique in order to include
elements of reality in their
paintings: here the grain of the
wood represents the material of
which the guitar is made, the
word 'Concert' denotes the
context in which it is
represented. The Cubist analysis
of the object, which results in its
deconstruction, is thus
complemented by means of a
poetic, associative element, and
this is emphasised by the colour
that is applied later.

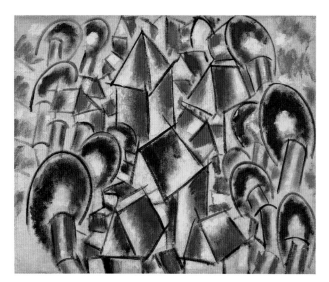

Fernand Léger
Argentan 1881 – Gif-sur-
Yvette, near Paris 1955

Landscape No. 2, 1913
Oil on canvas, 81 x 100 cm
(Inventory no. 13135)
Acquired 1961

Fernand Léger's adaptation of
Cubism was called tubism by
the critics – a term that derived
from his typical tubular forms,
which are apparent in this
painting in the tree trunks.

These shapes are supplemented
with cubes and pyramids for
houses and churches, and the
composition acquires rhythm
from its predominant colours,
green, blue, red and orange.
With the help of these simple
shapes and colour contrasts,
described by Léger as 'the
timeless means of making life
accessible artistically', he strove
for 'sculptural intensity'.

Fernand Léger
Argentan 1881 – Gif-sur-
Yvette, near Paris 1955

The Typesetting Machine, 1919
Oil on canvas, 81 x 65 cm
(Inventory no. GV 16)
On loan since 1971 courtesy of
PIN, the Friends of the
Pinakothek der Moderne

Léger's fascination with the
machine, for its cold, lustrous
perfection, dates from the time
of the First World War and the
artist's experiences as a soldier in
that conflict. The machine
became part of his works in the
years that followed, replacing
action or still life, being used as
the subject of both cubist- and
constructivist-inspired
compositions. The strong, richly
contrasting palette used here
engages with geometric shapes
that place the typesetting
machine in the service of a
dynamic interplay of colours.

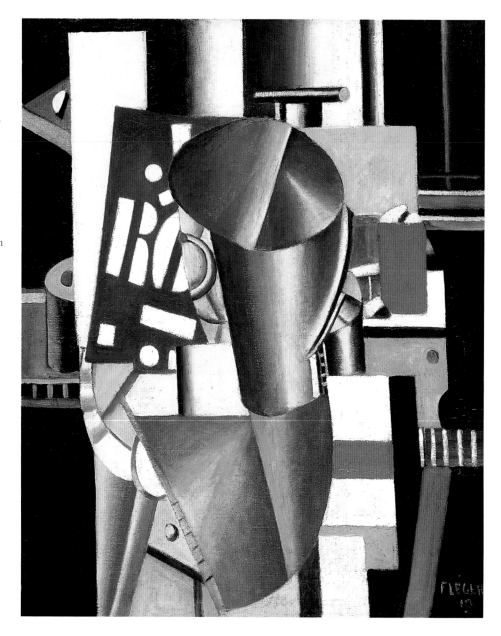

Robert Delaunay
Paris 1885 – Montpellier 1941

The Cardiff Team, 1913
Oil on canvas, 130 x 96.5 cm
(Inventory no. 13340)
Acquired in 1963

Delaunay has analysed the
objects in his painting in a
partially Cubist manner. It was
for him ultimately a question of
abandoning the actual subject of
the picture – the poet and art
critic Guillaume Apollinaire
described this as 'Orphism'.
Delaunay aspired to achieve a
composition of pure colours
which would translate the
dynamics of the modern spirit
via the intense effects of the
light of a clear, structured
mosaic of colour, represented in
this picture by the rugby
players, the Paris Ferris wheel,
the advertising hoarding, the
Eiffel Tower and the aeroplane.

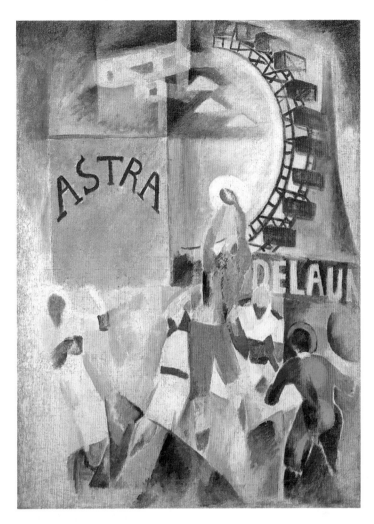

Juan Gris
Madrid 1887 –
Boulogne-sur-Seine 1927

The Bottle of Bordeaux, 1915
Oil on canvas, 50 x 61 cm
(Inventory no. 14237)
Bequest of Woty and Theodor
Werner, 1971

Juan Gris's still-life depicts
'synthetic Cubism' in its most
uncompromising form: the
bottle of Bordeaux, glass,
newspaper and table, even the
oval frame of the picture have
been layered one across the
other in a new and
unaccustomed arrangement, so
that the glass appears partially as
a sketched outline, the
newspaper is represented by
letters, and the bottle is depicted
as flat but displaying the typical
reflections of light on the glass.

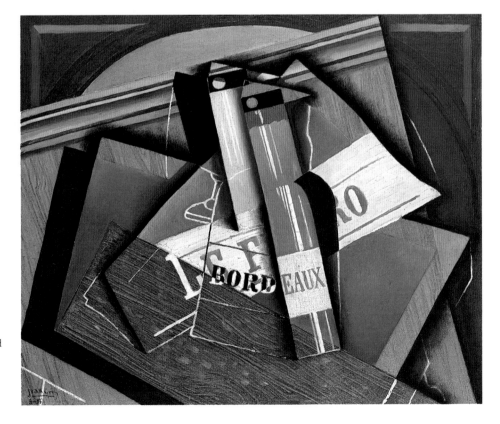

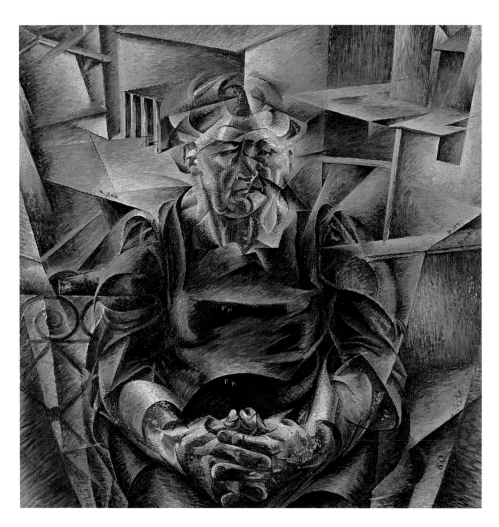

Umberto Boccioni
Reggio di Calabria 1882 –
Verona 1916

Volumi orizzontali, 1912
Oil on canvas, 95 x 95.5 cm
(Inventory no. 14611)
Acquired 1979

The portrait of his mother
reflects Boccioni's intense
engagement with analytical
Cubism. The artist adopts the
concept of multiple viewpoints
and a reduced palette, as well as
the fragmentation of objects
into different abstract shapes.
Over and above these
techniques, he also introduces
the element of movement, a
technique that was so essential
for the development of
futurism, which in Italy was
under way from 1909. The inner
and outer movement of the
subject find their expression in
dynamic, rounded forms, in the
ellipses and circles that form the
structure of the painting.

Gino Severini
Cortona 1883 – Paris 1966

The War, 1914
Oil on canvas, 60 x 50 cm
(Inventory no. 15036)
Acquired in 1987

In this composition Severini
strove to portray a 'plastic
synthesis of the idea of war'. In
fact it strikes the onlooker as a
modern allegory, as a
glorification of the machinery of
war that was employed in 1914.

The colourfulness of the painting
– the blue-white-red of the
French flag – is striking, and we
see depicted an imaginary
technical construction that
symbolises the military domains
of the navy, the artillery and the
air force. The cold yet
simultaneously dynamic character
of the composition leaves the
spectator wondering whether,
along with the futuristic
glorification of technology,
Severini's vision also voices anti-
war ideals.

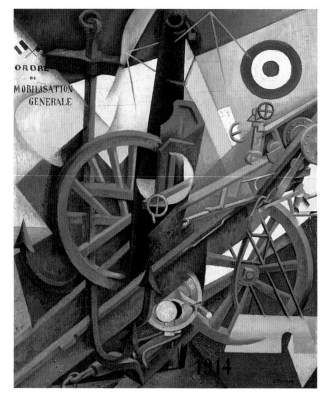

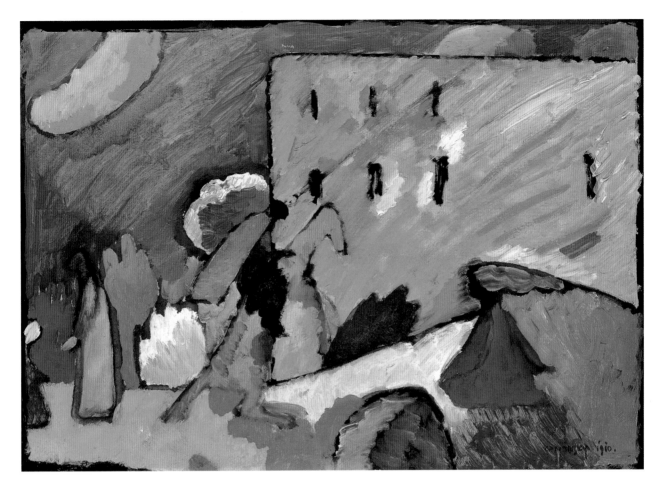

Wassily Kandinsky
Moscow 1866 – Neuilly-sur-
Seine, near Paris 1944

*Rider on the Bridge (Study for
Improvisation 3)*, 1909
Oil on board, 45 x 65 cm
(Inventory no. L 1713)
On loan from a private
collection since 1978

In *Rider on the Bridge*, a sketch in
oil, the powerful expression of
the colour of the composition
claims the spectator's attention
before the meaning of the
subject becomes apparent. The
different tones relinquish their
function as the colours of the
subject and amalgamate into a
warm, nocturnal harmony. The
fairytale motif of the rider recalls
themes that Kandinsky had
handled already in the paintings
of his Neo-Impressionistic
period. His new relationship
with colour, which fills huge,
mosaic-like areas laid out one
next to the other, points ahead to
his abstract 'improvisations' of the
following years.

Wassily Kandinsky
Moscow 1866 – Neuilly-sur-Seine, near Paris 1944

Dreamy Improvisation, 1913
Oil on canvas, 130 x 130 cm
(Inventory no. 14091)
Acquired in 1969 with the help of PIN, the Friends of the Pinakothek der Moderne

It is not by chance that a musical element is intimated in the picture's title *Dreamy Improvisation*. The painting reflects a spiritual ordering, comparable with a musical composition where both harmony and dissonance are present. Kandinsky especially wanted to summon up in his painting an inner vision that would confront the material world with a spiritual dimension. He wanted to create abstract compositions, which in the ordering of colour and within their structure of black lines and curves would represent an inner order of their own.

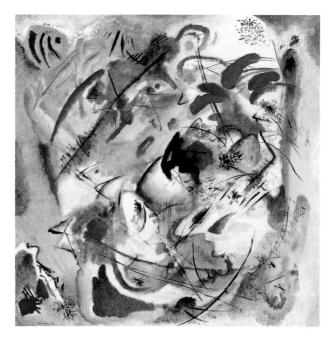

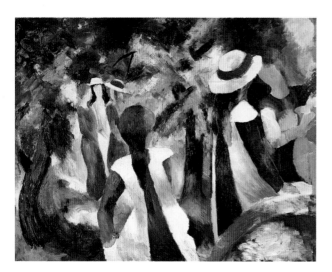

August Macke
Meschede 1887 – Perthes-les-Hurlus 1914

Girls under Trees, 1914
Oil on canvas, 119.5 x 159 cm
(Inventory no. 13466)
Donated by Sofie and Emanuel Fohn, 1964

Macke's compositions, each an image of a moment of happiness, painted in an intense palette and flooded with light, employ themes that evoke memories of the French Impressionists. In their particular perception of colour and light they relate, however, rather to Robert Delaunay, who wanted to portray in his paintings the greatest possible intensity of light by means of the simultaneous contrast of colours. Macke always remained true to an object-related form of artistic expression, and this theory of colour, inspired by pointillism, became the foundation of a form of painting in which objects were abstracted into radiant pools of colour.

Franz Marc
Munich 1880 – Verdun 1916

The Mandrill, 1913
Oil on canvas, 91 x 131 cm
(Inventory no. 13467)
Donated by Sofie and Emanuel Fohn, 1964

The mosaic of pools of colour, almost blending into one another, by which Franz Marc creates the abstract image of a monkey, is founded on both his adoption of Robert Delaunay's Orphism and his own concept that the cosmic rhythm of Nature is expressed in the many tones of the sheer collision of the colours of his palette. Everything – man, beast and plant – is incorporated into this primeval, eternal collision, and Marc wanted to make visible again in his painting that which lies beneath the material appearance of things.

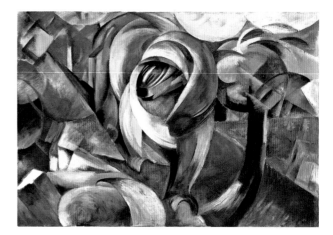

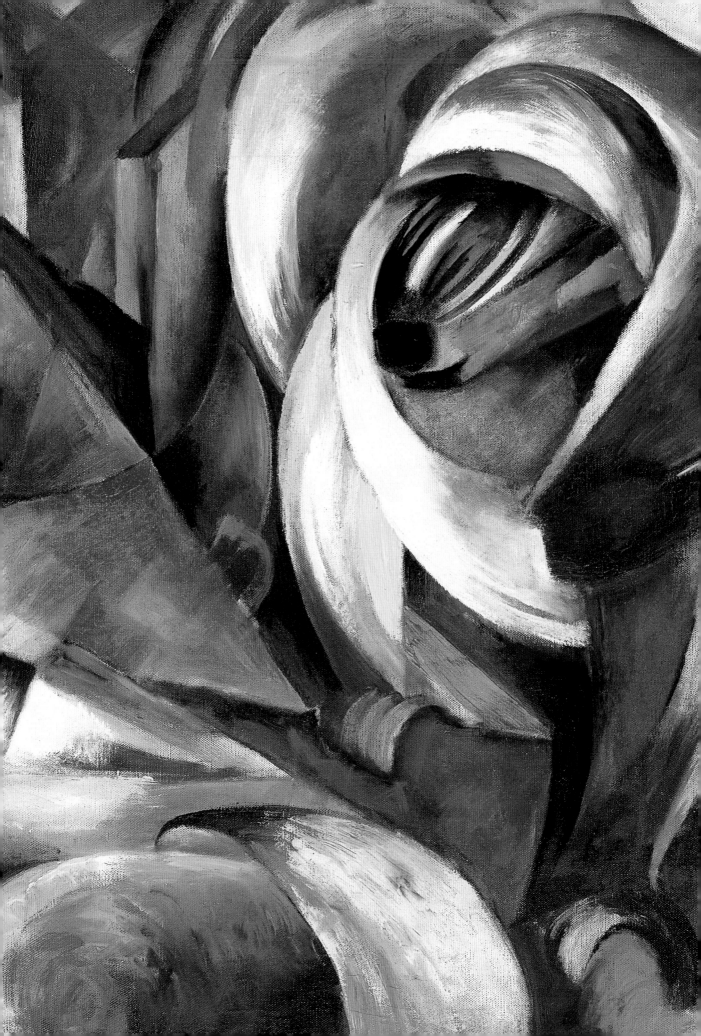

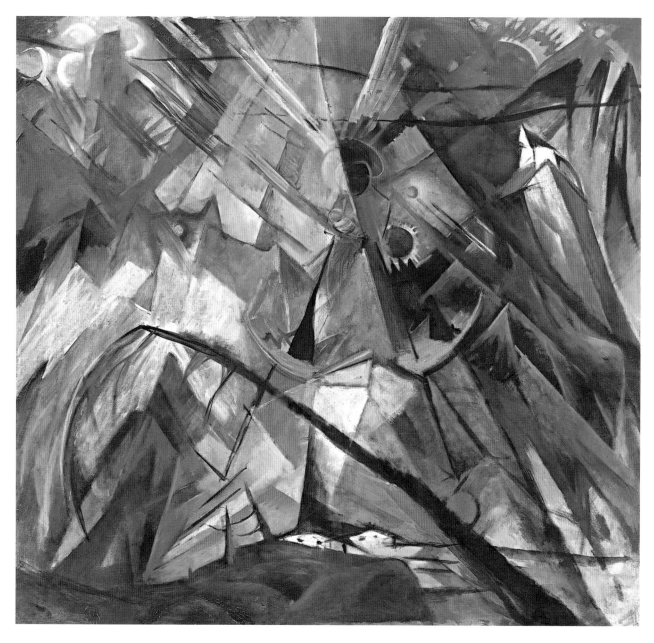

Franz Marc
Munich 1880 – Verdun 1916

Tyrol, 1914
Oil on canvas, 135.7 x 144.5 cm
(Inventory no. 10973)
Acquired 1949

Tyrol was painted in 1913 but a year later Franz Marc revised it in the light of a more spiritual expression, which changed the work into an allegory not only of Christian salvation but also of the historical catastrophe that was unfolding in 1914. Central to the composition's clear colour structure is the head of a veiled Madonna, who stands protectively over the desolate and wretched landscape of the Tyrol. She promises salvation from the apocalypse that is conjured up by the stormy mood of the painting and the twisted, skeletal trees.

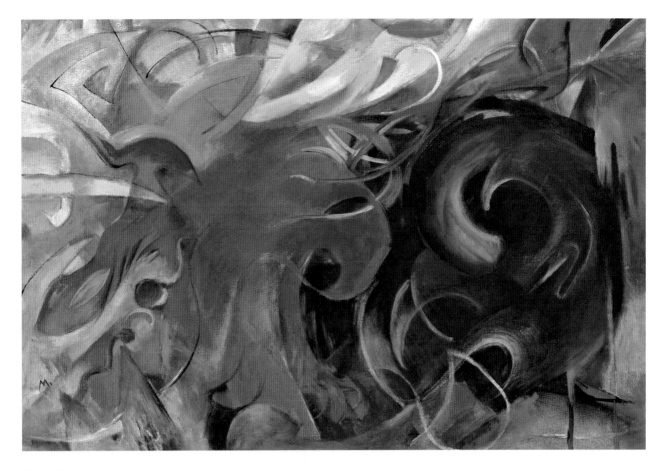

Franz Marc
Munich 1880 – Verdun 1916

Fighting Forms, 1914
Oil on canvas, 91 x 131.5 cm
(Inventory no. 10972)
Acquired 1949

Marc's path towards abstraction
was predetermined by his
conviction that the primal
purity of Nature could not be
depicted through the
representation of human beings,
or of animals, but only in the
portrayal of a cosmic vision of
Nature. In 1914 he created a
series of paintings – *Cheerful
Forms*, *Forms at Play* and
Shattered Forms; this picture
belongs to that series. He paints
a black shape and a red one:
they approach each other, the
latter appearing as the German
eagle in *Purgatory of the War*,
which is envisaged by Marc as a
purifying apocalypse.

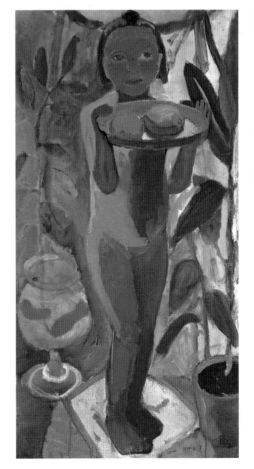

Paula Modersohn-Becker
Dresden 1876 –
Worpswede 1907

Child with a Goldfish Bowl,
1906–07
Oil on canvas, 105.5 x 54.5 cm
(Inventory no. 13468)
Donated by Sofie and Emanuel
Fohn

Between 1900 and 1907 Paula
Modersohn-Becker was in Paris
where she engaged with the
painting of van Gogh, Cézanne
and Gauguin. These artistic
experiments come to fruition in
her painting of the little girl
proffering two lemons on a tray.
The sculptural stance of the
child, and the exotic plants and
goldfish bowl, recall the work of
Gauguin. The expressiveness of
this composition, characterised
by its utter simplicity, suggests a
broader, symbolic level of
interpretation.

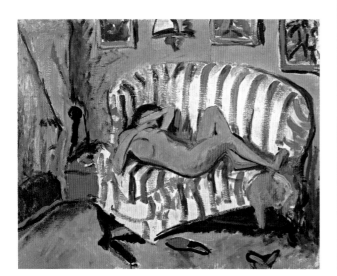

Erich Heckel
Döbeln, Saxony 1883 –
Radolfzell 1970

Girl Lying Down, 1909
Oil on canvas, 96.5 x 122 cm
(Inventory no. 11341)
Acquired 1952

The colourful intensity of *Girl Lying Down* recalls the influence of the French Fauves on the artists of the Brücke movement; however, the spontaneity of the use of colour and the directness of the choice of subject demonstrate the essential difference between the two 'schools'. While Matisse devoted himself to harmony and ornamental beauty in his works, Heckel was concerned with youth, vigour and unconventionality – concepts that may be considered as representative of the programme of the Brücke artists and which are also distinctive features in this painting by Heckel, which is permeated with light and a joy in living.

Erich Heckel
Döbeln, Saxony 1883 –
Radolfzell 1970

A Clear Day, 1931
Oil on canvas, 121 x 97 cm
(Inventory no. 14534)
The Martha and Markus Kruss bequest, 1977

Water and sky, vegetation and rocks are depicted in one clear, all-embracing structure. They are part of a brilliantly clear universe in which the naked woman in the foreground acquires a mythical character. Against this background, her body, reminiscent of African sculptures, becomes not only a symbol for the one-ness with Nature sought by the artists of the Brücke movement – as opposed to the degeneration of civilised man – it appears transfigured, and thus also represents the Romantics' notion of a secret union of man with Nature.

Ernst Ludwig Kirchner
Aschaffenburg 1880 –
Frauenkirch, near Davos 1938

A Portrait of Dodo, 1909 (verso *Masquerade on the Street*, 1910)
Oil on canvas, 114.5 x 112 cm
(Inventory no. 13061)
Acquired 1960

The portrait of Dodo, Kirchner's model in Dresden, combines the warm colours of yellow, red and orange for the chair, the floor and the dress of the young woman, with the dark blue of her face. Not least, this richly contrasting palette expresses the individuality of Kirchner's painting when one compares it with the art of the French Fauves. Kirchner, who was a member of the Brücke group, combines the vigour and light of the French palette with an expressiveness that does not simply adhere to the apparent beauty of things, but rather incorporates a psychological vision of them.

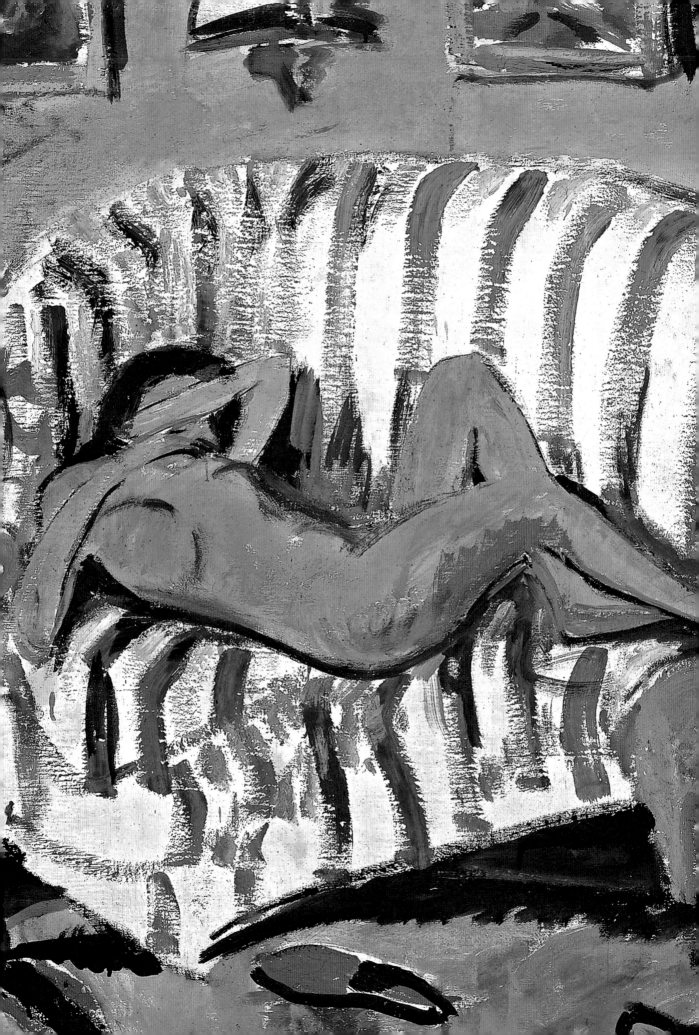

Ernst Ludwig Kirchner
Aschaffenburg 1880 –
Frauenkirch, near Davos 1938

Naked Figures at Play, 1910
Oil on canvas, 77 x 89 cm
(Inventory no. L 1643)
On loan from a private
collection since 1976

In their endeavours to find an
existence beyond the
conventions and taboos of a
bourgeois society, the painters of
the Brücke group sought
freedom in Nature, particularly
through their expeditions

around Dresden on the
Moritzburger lakes. In the
tradition of Cézanne, but also
bearing in mind the background
of a long Arcadian tradition in
European painting, Kirchner
depicts his friends bathing, and
in so doing creates a vision of a
modern golden age in powerful
colours and spontaneous brush
work.

Ernst Ludwig Kirchner
Aschaffenburg 1880 –
Frauenkirch, near Davos 1938

Elisabethufer, 1913 (verso *Bathers
on the Beach*, 1913)
Oil on canvas, 83.5 x 94 cm
(Inventory no. 14530)

The Martha and Markus Kruss
bequest, 1977

The oppressive townscape,
alienated from its citizens, was
an important theme for
Kirchner after his move to
Berlin. In *Elisabethufer*, an
autumn scene, the artist spreads

a melancholy mood over the
city and this is emphasised by
the aggressive red of the church,
repeated in the pillars of the
bridge. Two people walking are
squeezed into the bottom right-
hand corner of the picture, and
they observe the scene, with its
tightly packed houses and

deserted streets, as lonely,
marginalised figures.

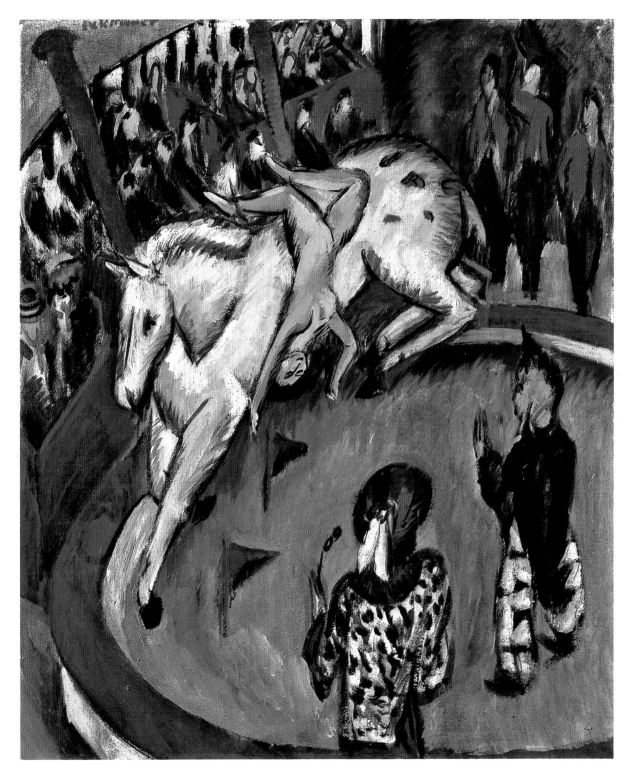

Ernst Ludwig Kirchner
Aschaffenburg 1880 –
Frauenkirch, near Davos 1938

Circus, 1913 (verso *Nude on a Truckle Bed*, 1910)
Oil on canvas, 120 x 100 cm
(Inventory no. 14715)
Acquired 1979

From the late nineteenth century onwards artists were preoccupied with the fringes of society, finding there an echo of their own existence, lived in isolation from the everyday and the normal. Kirchner's depiction of a circus, inspired by Seurat's famous painting, adds to the exotic element of the worlds of theatre, circus and variety a certain aggression and unease, expressed here in the red, pink, black and grey portrayal of the arena. An outsized horse with a daring acrobat performing her tricks on his back dominates the scene, which is observed by an anonymous and passive audience.

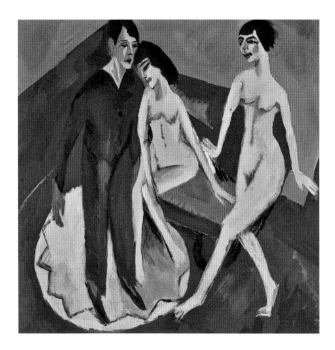

Ernst Ludwig Kirchner
Aschaffenburg 1880 –
Frauenkirch, near Davos 1938

The Dancing School, 1914
Oil on canvas, 114.5 x 115.5 cm
(Inventory no. 13350)
Acquired 1963

The Dancing School is a
programmatic picture, a
provocative self-portrait that
shows Kirchner in the role of
the Fool. Dressed as Harlequin,
melancholy and lost in thought,
he stands motionless beside two
naked women, one of whom is
nestling up to him. Even this
closeness, apparently, is capable
of easing only a little the
isolation of the artist in the
modern age. The lack of
comprehension that he
encounters in his search for
artistic truth renders him
excluded: he is able to enjoy the
freedom of playing the Fool, but
his art is accessible to only a
few.

Ernst Ludwig Kirchner
Aschaffenburg 1880 –
Frauenkirch, near Davos 1938

Self-Portrait as an Invalid, 1918
Oil on canvas, mounted on
plywood, 59 x 69.3 cm
(Inventory no. 15580)
Acquired in 2002 with the help
of the Kulturstiftung der Länder
[the regional foundation for
culture], the Ernst von Siemens
Art Fund, and the Bayerische
Landesstiftung [the Bavarian
regional trust]

Kirchner's experience of the
First World War (Kirchner was
sent back from the Front on the
grounds of a mental breakdown
in 1915) was the cause of his
depression and hallucinations,
which resulted in an enforced
period in a sanatorium in the
Swiss Alps. The aggressive
colours of his palette and the
narrow confines of the room in
which the artist depicts himself
lying in bed seem to reflect not
only his physical condition, but
also his life now as an artist in
enforced retreat – this situation
was to colour the rest of
Kirchner's life.

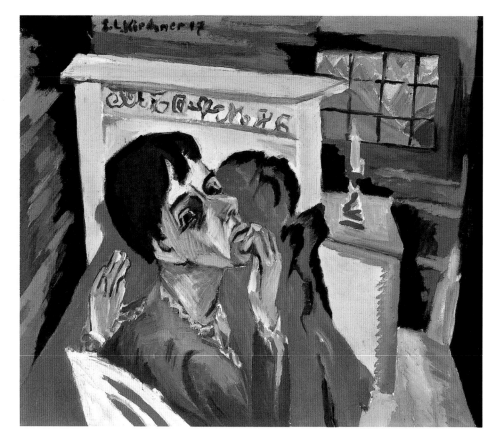

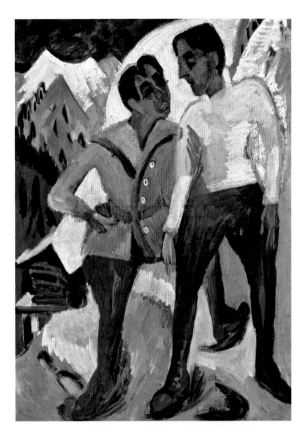

Ernst Ludwig Kirchner
Aschaffenburg 1880 –
Frauenkirch, near Davos 1938

The Two Brothers M (Mardersteig),
1921
Oil on canvas, 168 x 120.2 cm
(Inventory no. 15269)
Acquired 1991

The Mardersteig brothers, one
of whom was a publisher
associate of Kirchner, belonged
to the limited personal circle
with whom Kirchner had close
human contact in Davos. They
appear in this large double
portrait, deep in conversation,
against the background of the
pink and light blue angular
silhouette of the Alps. The way
in which they are depicted
reflects Kirchner's composed
artistic style: in the 1920s he
sought an abstract, simplified
style, which clearly indicates his
orientation towards Picasso, and
this is reflected here in the facial
features of the brothers.

Karl Schmidt-Rottluff
Rottluff, near Chemnitz 1884 –
Berlin 1976

*Landscape with a Woman carrying
Water,* 1919
Oil on canvas, 87 x 101 cm
(Inventory no. 14521)
The Martha and Markus Kruss
bequest, 1977

The theme of this painting was
apparently inspired by Schmidt-
Rottluff's time as a soldier in
Russia during the First World
War. However, the scenery of the
countryside, with its straw-roofed
houses, was painted in Holstein, a
fact that is not apparent from the
powerful palette of the painting,
the colours disengaged from
their subject, and the folkloric
charm of the woman carrying
water, combined with the
symbolic reference to obedience
and subservience in the form of
the two buckets suspended from
a yoke. Thus the painting appears
to represent the artist's reflections
on the war: the image is shot
through with his memories, and
represents an artistic expression
of his experiences at the Front.

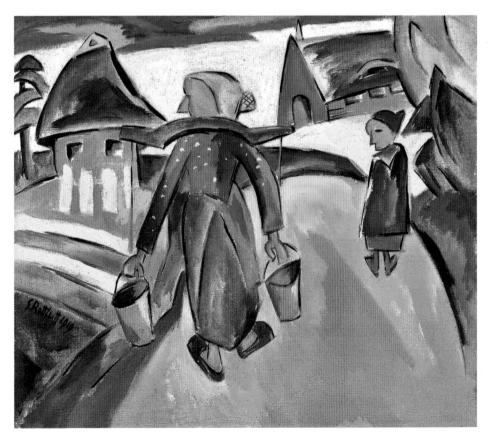

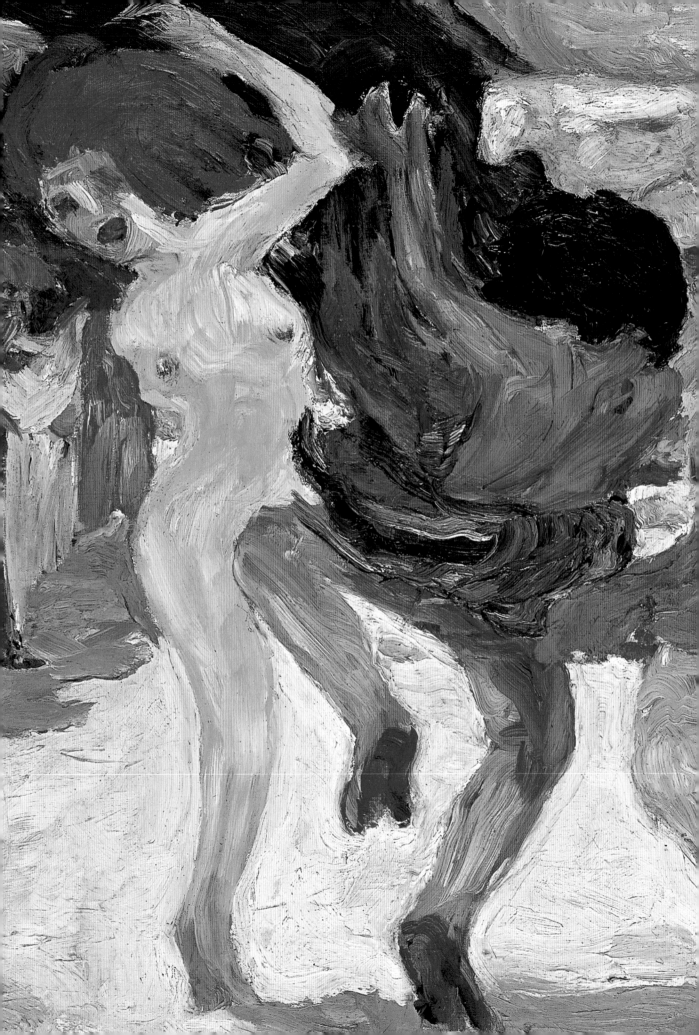

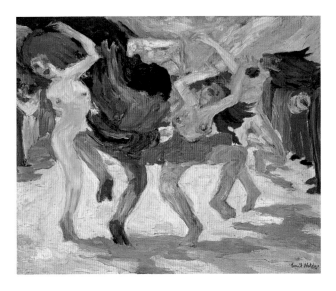

Emil Nolde

Nolde, North Schleswig 1867 –
Seebüll 1956

Dance around the Golden Calf,
1910
Oil on canvas, 87.5 x 105 cm
(Inventory no. 13351)
Acquired 1963

This religious composition, in
which Nolde combines
Christian belief with pagan
imagery, was painted following
his affiliation with the artists of
the Brücke group in 1909. The
intensity of belief, which it was
so important for Nolde to bring
to artistic expression after his
long illness, is rendered here in
the dance to which the Israelites
abandon themselves before the
idol. Nolde's painting is created
as a depiction of the joy of
living through its luminescent,
glowing colours and the
spontaneous and expressive
application of the paint. For
Nolde this joy in life sprang
from a deep belief in both art
and reality rather than faith in
the Bible.

Emil Nolde

Nolde, North Schleswig 1867 –
Seebüll 1956

South Sea Maiden, 1918
Oil on canvas, 66 x 58 cm
(Inventory no. 15252)
Acquired 1991

South Sea Maiden sublimates
Nolde's experiences of a South
Seas expedition into an image
of exotic beauty. In this
painting, whose warm tones
seem to capture the very
essence of the South Seas, the
artist varies the motif of the
circle, even in the circular
rhythms of the application of
the paint; it is repeated in the
round earrings, in the flowers
worn by the girl and in the
shape of her breasts. The
cheerful grace of the girl's
presence and her shining blue
eyes stand in sharp contrast to a
primitive quality, which the
Expressionists sought in their
imaginary or actual excursions
to distant civilisations.

Otto Müller

Liebau 1874 – Breslau 1930

Two Girls in the Grass, 1920–25
Oil on canvas, 89.5 x 122 cm
(Inventory no. 11340)
Acquired 1952

In this, as in many other
Expressionist compositions,
actions that occur in harmony
with Nature become the symbol
of a paradisiacal, timeless state.
Here in Otto Müller's painting
this is further emphasised by the
stylisation of the human bodies
and the vegetation. The slim
figures of the two girls, whose
facial features cannot be seen,
have a stereotypical effect and
correspond to many other
paintings of nudes by Müller.
The drawing of the body is
always closely connected to the
formal structure that surrounds
it, and this presupposes its
consequent stylisation; thus the
bodies project themselves
harmoniously into the natural
structures that surround them.

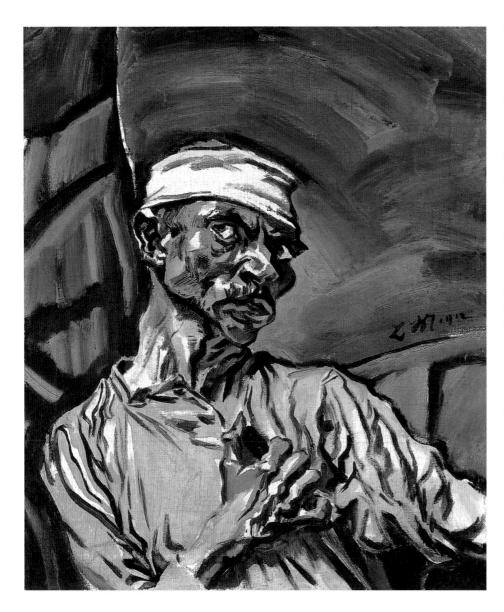

Ludwig Meidner
Bernstadt, Silesia 1884 –
Darmstadt 1966

The Suicide, 1912
Oli on canvas, 69.4 x 59 cm
(Inventory no. 15255)
Acquired 1991

The self-portrait depicting the
artist in a state of suffering
reflects the phase in Meidner's
artistic development before the
First World War. In the period
around 1912 he painted
apocalyptic city landscapes
marked by decline and
destruction, and suffered in so
doing: 'So, I have spent the best
months of summer slouched in
front of reeking canvases, whose
every surface, wisp of cloud and
torrent of water spoke of the
earth's misery…,' wrote
Meidner, whose self-portrait
expresses this intense sympathy
symbolically in the white
bandage around his head and
the clenched hand over his
heart.

Wilhelm Lehmbruck
Duisburg 1881 – Berlin 1919

The Fallen Man, 1915–16
Bronze, 78 x 239 x 83 cm
(Inventory no. B 397)
Acquired 1963

The formal image of *The Fallen
Man*, rudimentary yet
impressive, should be seen as
Lehmbruck's artistic response to
the First World War – a
monument dedicated to
Europe's youth slain in the war,
but also a memorial that
embraces a much wider realm
of ideas. Lehmbruck had
imagined that the sculpture
would be installed in a niche
below a classical pediment and

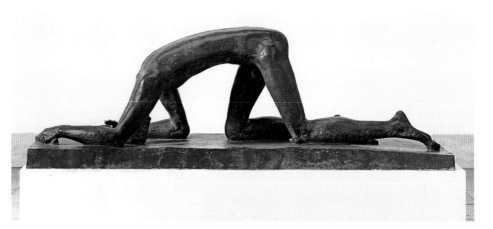

carry the title *The Suffering of
Humanity*: the fallen youth
symbolizes this concept in such
a way that he does not appear as
a sacrifice, but rather as an

individual bearing the weight of
the consciousness of his fate.

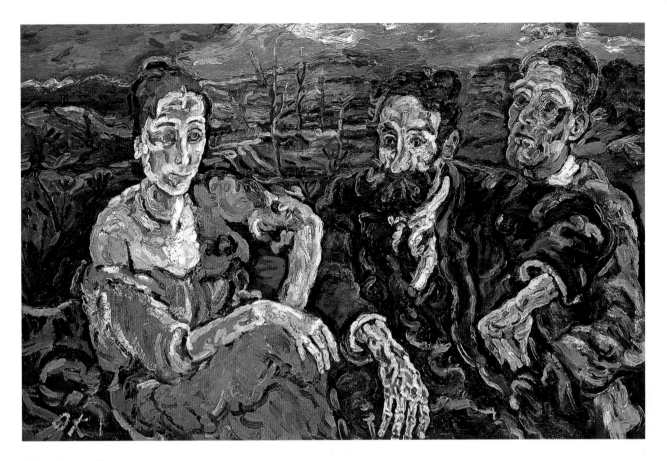

Oskar Kokoschka
Pöchlarn 1886 –
Villeneuve 1980

The Emigrants, 1916–17
Oil on canvas, 95 x 146 cm
(Inventory no. 13465)
Donated by Sofie and Emanuel
Fohn, 1964

The group portrait, executed
during Kokoschka's time in
Dresden, shows the artist with
friends, the actress Käthe
Richter and the poet Fritz
Neuberger, who both apparently
confronted the political situation
just as helplessly as Kokoschka
himself did. Kokoschka's style of
painting, which owes much to
van Gogh and Gauguin, is
composed of many short strokes
of colour and reflects the
vulnerability of its subjects; the
landscape in the background –
the sombre, stormy sky, the
leafless trees – captures the
feeling of their desolation and
their melancholy.

Lovis Corinth
Tapiau, East Prussia 1858 –
Zandvoort, Holland 1925

Thomas and Wilhelmine, 1916
Oil on canvas, 165.2 x 95.4 cm
(Inventory no. 15247)
Acquired in 1992 with the aid
of the Theo Wormland
Foundation

Corinth's children, Thomas and
Wilhelmine, who posed as
models for him, appear in this
portrait curiously animated by
means of the artist's swift
application of paint over the
canvas. His drawing, at once
masterly and distorted, reveals
not only the true appearance of
both children, but also the strain
they feel remaining still in one
position. Portraiture as such
becomes a theme; the question
is, to what extent is it possible
to capture in a painting both
the physical and the mental
presence of a subject?

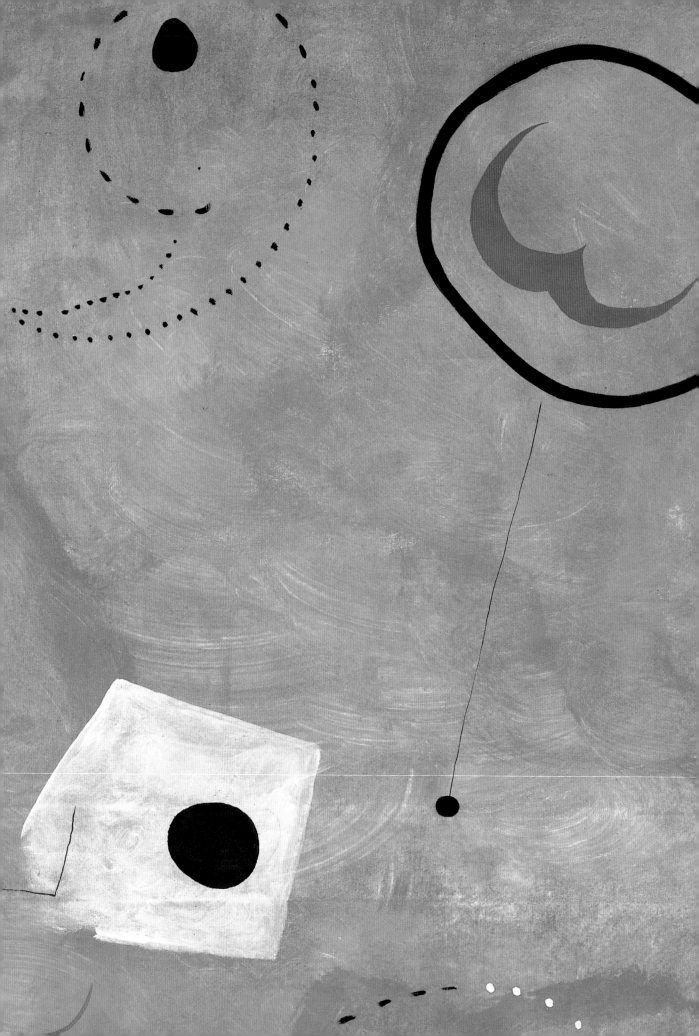

The 1920s

Retour à l'ordre, New Realism, Surrealism, Bauhaus

With critical hindsight, the period between the two World Wars was marked by a pause in the domain of the creative arts too, a pause that appears to question the achievements of the avant-garde movements of the early years of the century. This reflective stance is expressed on the one hand in the hostility of the Dadaists and the Surrealists towards the contemporary cultural and political situation; while on the other hand a tendency towards a new classicism emerged – a return to tried and tested forms and themes. This accompanies a resumption of a figurative style of painting, most potently expressed in Picasso's works of the period. The large painting *Mother and Child* occupies a special position in his oeuvre and it also sets an important tone in the collection of the Pinakothek der Moderne. *Mother and Child* (1921) is a characteristic example of the *retour à l'ordre* [return to order], which in Picasso's work combines the timelessness of classicism with an impressive massiveness of form and a great sense of peace in the composition. This redeeming stability, seemingly the antithesis of contemporary political and social

upheavals, finds its opposite pole in the work of Max Beckmann, whose paintings depict a world shaken to its core, torn apart – not only in *Before the Masked Ball*, where the ball's participants, estranged from one another, are constrained within a narrow space, but also in *Young Argentinian*, painted in 1929. This portrait is imbued with a deep melancholy that penetrates what appears at first to be a conventional portrait and seems to undermine its external classicism. The impression of enigma, of disquiet, also defines *Large Still-Life with Telescope*. Painted in 1927, this work reveals not only the important influence of French painting on Beckmann, but also Expressionism and New Realism as the basis of his mature style, of which the Pinakothek der Moderne offers a wealth of examples. Beckmann's art reflects reality like a distorting mirror, in which we see the black outlines of monumental forms lurch around.

In contrast, Otto Dix seems to be an objective observer, almost non-manipulative. It is only after a second look that one realises the artist's vision is so unsparing that there is only a fine line separating his

Joan Miró,
Composition
(Detail from page 50)

paintings from being a kind of caricature, as the *Portrait of the Photographer Hugo Erfurth* of 1925 illustrates.

This slight shiver, the doubt in the permanence of the traditional that was evident everywhere as artists sought new ways to deal with the representation of reality, finds an intense form of expression in de Chirico's paintings. *The Disquieting Muses* belongs to the artist's images of city landscapes: empty of people, a maelstrom-like, distorted perspective seems to conceal an eerie presence. Is it the ghost of classical antiquity, forgotten by the modernists, a sacrifice to their loss of meaning, that seeks to gain entry here once more? Giorgio de Chirico's art, which he himself described as *pittura metafisica* [metaphysical painting], was of enormous importance for some of the Surrealists. Max Ernst, whose work is widely represented in the Pinakothek der Moderne, was inspired by de Chirico's faceless manikins, at once mysterious and absurd, and his spaces with their unresolved perspectives. His paintings, too, depict fields of the unconscious, dream visions: they are irrational assemblages of the disparate, in which Max Ernst seeks stylistically and technically to create ever new technical possibilities to illustrate his visions. While the early work *Birds-Fish-Snake* translates the collage technique developed by Ernst into paint, *House Angel* falls back on a hyper-naturalistic style of painting that renders the nightmare vision it depicts surreal. René Magritte adopts the same approach: his work is all about the interfaces of reason and intuition. Is language truly a completely rational system – as its strict grammatical structure would have us believe? How severely would our trust in our world be shaken if we were no longer sure how to identify the individual elements of the universe that surrounds us? A small painting, *La Clef des songes*, poses this question: like a page from a dictionary the picture places objects next to their descriptions, but there is only one

instance where the caption is 'correct', and thus the spectator must confront Magritte's assertion that no object is so united with its name that it could not be given a different one.

Salvador Dalí keeps the promise of the Surrealists' demand to explore the unconscious, dreams and hallucinations as sources for creative work in a highly personalised adaptation of Freud's psychoanalysis. *The Enigma of Desire* takes as its theme Freud's description of the Oedipus complex: Dalí introduces himself into his own painting with a tortured self-portrait through which he translates the tension and conflict-ridden triangular relationship between the child, its father and its mother into a disturbing scenario. In a wilderness landscape beneath a glistening sun lies a yellow creature, full of holes, similar in consistency to a piece of cheese, and from this a head, Dalí's self-portrait, is pressed to the ground. In the background the two other key figures of this drama can be seen, painted small: the mother as a naked, blood-flecked half-nude, and the father, who is fighting with a lion.

Perhaps nothing makes the stylistic range of Surrealism so clear as the confrontation of Salvador Dalí and Joan Miró. While the former translates his own paranoia into nightmarish landscapes, Miró demands that art should give voice to the 'fire of the soul'. His *Composition* of 1925 is typical of the works of his early Surrealist phase: magical symbols hover over a cloudy blue background and join together to form a purely abstract dream picture.

André Breton, the poet, theoretician and protagonist of the Surrealists, recognised Pablo Picasso for his significance in the movement's popularisation.

In fact a far-reaching new direction announces itself in Picasso's work from the end of the 1920s: he now turns the illusionary manner of representation, which lay at the heart of his neoclassical paintings, into the monstrous and the unreal. He uses it to create images, the innermost heart of which appears to

be turned inside out. Even his *Woman* of 1930 portrays a desperate, shrieking, exposed creature whose 'true' nature – in the surrealistic sense – is revealed in artistic deformity.

Surrealism, which in the 1920s had its centre in Paris, was not without consequences for other the artistic centres of Europe. The Bauhaus movement limited the principal theory of Surrealism – human intelligence – too narrowly by the application of reason and logic. In the Bauhaus the intention was to rationalise art in the constructivist sense and make it useful for design. The artists there, among them Oskar Schlemmer, Lyonel Feininger, Wassily Kandinsky and Paul Klee, were, however, sceptical about these concepts. Appointed in 1920 by the founder of the Bauhaus, Walter Gropius, they persisted in pursuing a transcendental effect in art: they believed that although the basic elements of the Bauhaus concept were teachable, in its realisation 'genius' was nevertheless just as important a component as calculation, rules and construction. Despite the extreme simplification of form, it was precisely works such as Schlemmer's *Dancer* or Feininger's *Troistedt* that illustrated their theory in the fairytale effect of dissolution of form, which leaves the real substance of the subject visible – but through a transparent veil.

Paul Klee, whose work is defined by its lyrical effect, had direct contact with the Paris Surrealists, and took part in their first exhibition in Paris in 1925. Even during his years in Munich, a period represented in the Pinakothek der Moderne by his *Vollmond* [*Full Moon*] – one of his principal works, executed in 1919 – Klee's art was already characterised by its claim to reveal to the spectator new and spiritual worlds and to release him for a short time from earthly existence. *The Dance of the Grieving Child* and *The Limits of Understanding* make a theme of this human dilemma between spiritual freedom and physical limitation, while *Plants Growing at Night* captures in an abstract form growth and death in Nature, the eternal cycle of light and shadow, and despite all formal simplification it seems to cling to some ultimate mystery.

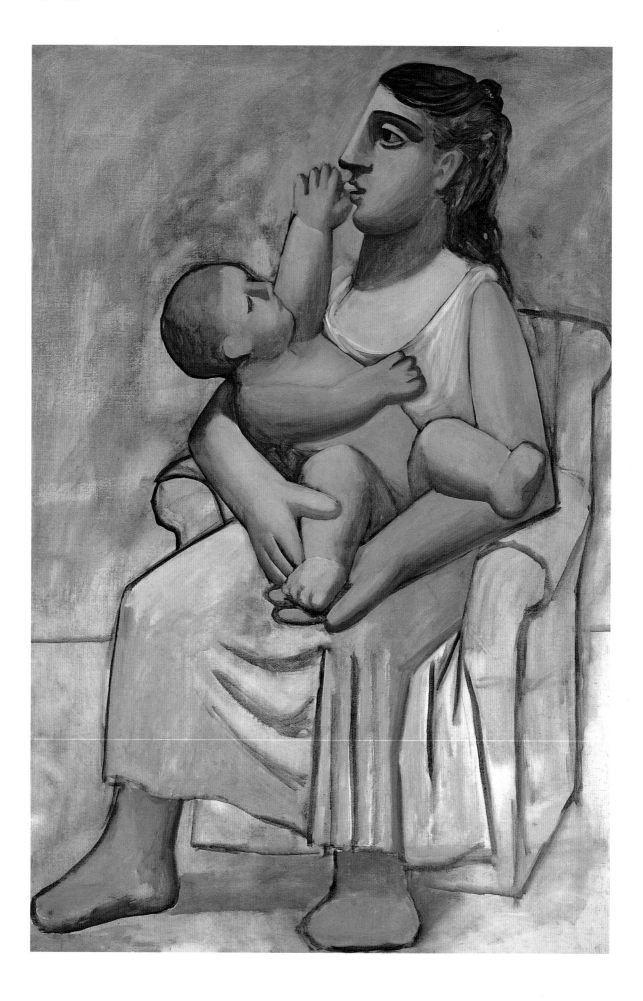

Pablo Picasso
Malaga 1881 – Mougins 1973

Mother and Child, 1921
Oil on canvas, 154 x 104 cm
(Inventory no. 14635)
Acquired 1980

A typical work of Picasso's
classical phase, this composition
is drawn with a great sense of
balance and peace, and with a
monumentality that
encapsulates the classical spirit
in a modern formula. For
whilst this image embodies
clear references to the antique –
in the portrayal of the
garments, in the woman's
profile, in the restraint of her
expression – it none the less
reflects conscious simplicity of
presentation, the influence of
the modernists in general and
of Cubism in particular.

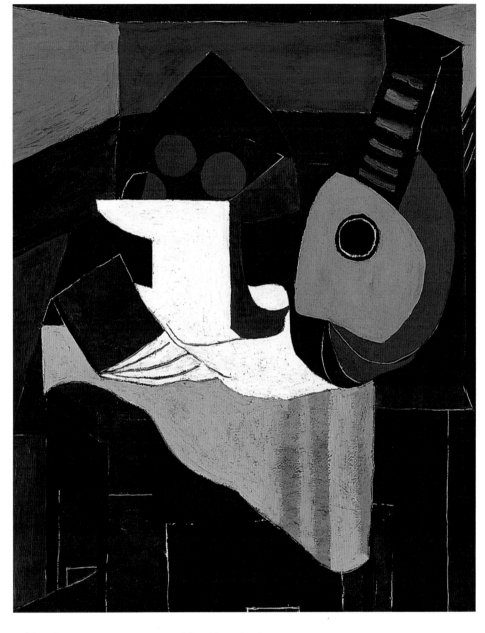

Pablo Picasso
Malaga 1881 – Mougins 1973

Book, Bowl of Fruit and Mandolin,
1924
Oil on canvas, 110 x 80.4 cm
(Inventory no. 14244)
The Woty and Theodor Werner
bequest, 1971

The still-life composition
assembled in the corner of a
room and comprising a bowl of
fruit, a book and a stringed
instrument, recalls similar
compositions of the seventeenth
century. Picasso, whose work
during the 1920s was a
conscious engagement with the
antique and the classical phases
of the older style of painting,
submits his subject to a cubist
analysis: side and top views are
combined, a two-dimensional
viewpoint negates the plastic
analysis, and the contrast
between light and dark areas of
colour results in a graphic
effect, which exposes the box-
like space of the room as an
artistic construction.

Max Beckmann

Leipzig 1884 – New York 1950

Before the Masked Ball, 1922
Oil on canvas, 80 x 130.5 cm
(Inventory no. 13402)
Acquired 1963

Beckmann's six friends and relatives seated together in a narrow room, already dressed for a masked ball, seem to be anticipating some sad, even frightening, event. Deep in thought, each remains in position, tired, isolated from the others, and surrounded by mysterious attributes. Only the artist, wearing a black eye mask, turns towards the spectator as if to a curious intruder, as if even he cannot break the sad spell that weighs heavily on this ashen-coloured tableau.

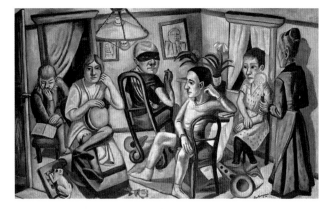

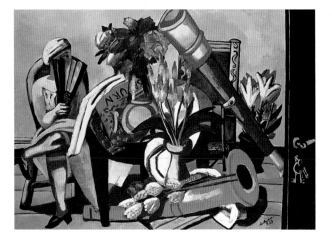

Max Beckmann

Leipzig 1884 – New York 1950

Large Still-Life with Telescope, 1927
Oil on canvas, 141 x 207 cm
(Inventory no. 13454)
Donated by Sofie and Emanuel Fohn, 1964

The *Large Still-Life with Telescope* is a puzzling picture in which the promise of the opening door draws one's attention but yet does not reveal the meaning of the picture. The decorative character of this composition, rich in colour, with several bunches of flowers, the telescope and the wind instrument, is imbued with the inherently peaceful beauty of Matisse's work, but the central reference to Saturn links it to a tradition in which the artist, in the guise of a pensive melancholic, conceals a deeper meaning behind the external beauty of his images.

Max Beckmann

Leipzig 1884 – New York 1950

Young Argentinian, 1929
Oil on canvas, 125.5 x 83.5 cm
(Inventory no. 14375)
Donated by The Günther Franke Foundation, 1974

For all its elegance, the portrait of the young Argentinian is deeply melancholic and introverted. Beckmann depicts the elegant young man as if he is entrenched behind an attitude of conventionality. His tuxedo, the clearly structured, simple background of the picture and the austere pose of the young man we see here convey the atmosphere of an old master portrait, but the young man's vulnerability and sensitivity appear to break through the outer mask of his face: his dark eyes are sunk beneath a white, mask-like brow and the nervous blush on his cheeks hides his pale complexion.

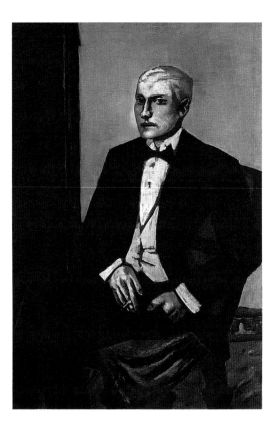

Otto Dix
Untermhaus, near Gera 1891 –
Singen 1969

*Portrait of the Photographer Hugo
Erfurth*, 1925
Tempera on panel, 75 x 60 cm
(Inventory no. 13459)
Donated by Sofie and Emanuel
Fohn, 1964

The precision with which Otto
Dix portrays his friend the
photographer Hugo Erfurth
seems to transcend the accuracy
of photography: materiality and
structure, inner and outer
demeanour are captured with an
intensity of which only painting
is capable, and in this way Dix
quite consciously places his art
against the background of
photography: 'We wanted to see
things completely naked and
clear – almost without artifice.'
This was Dix's vision, a concept
in which a meticulous
observation of nature was
inspired by Germany's old
masters.

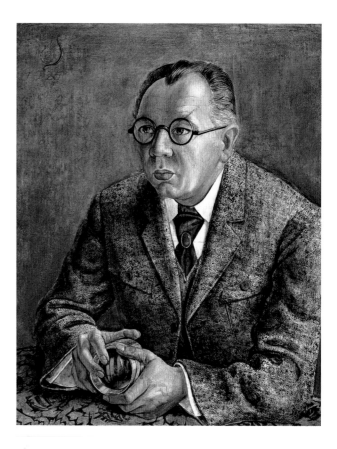

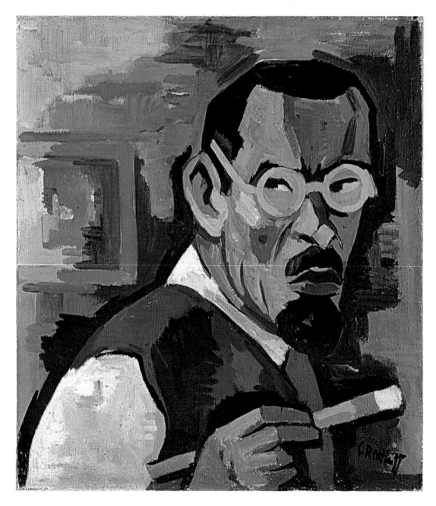

Karl Schmidt-Rottluff
Rottluff near Chemnitz 1884 –
Berlin 1976

Self-Portrait, 1928
Oil on canvas, 74 x 65 cm
(Inventory no. 11739)
Acquired 1953

By 1928, the year in which *Self-
Portrait* was painted, the Brücke
– the determining alliance of
Expressionist artists that was so
important both for the history
of twentieth-century art and for
the artist Schmidt-Rottluff
himself – was long since history,
but this self-portrait of 1928 still
reflects that period, so significant
for him artistically. He applies
the paint with energetic, but
calculated rather than
spontaneous brush strokes, and
constructs his own portrait with
sketch-like coloured shapes; in
this way, the particular intensity
of his gaze remains within the
long tradition of self-portraiture.

Karl Hofer

Karlsruhe 1878 – Berlin 1955

Grand Carnival, 1928
Oil on canvas, 102.5 x 130.5 cm
(Inventory no. 13461)
The gift of Sofie and Emanuel
Fohn, 1964

Hofer's representation of the
carnival is not at all a joyful
picture, as its title might lead
one to expect. In the portrayal
of a row of people dressed up,
bathed in a pallid light, behind a
raised stage curtain, the artist
presents us rather with a sad,
puzzling image: the dancer
dressed in black in the
foreground, his face in shadow,
clasps his partner in a manner
that is almost threatening. In the
background someone is
screaming, and an old man who,
as a representative for the other
fools, appears to be
contemplating the empty
masquerade of humanity.

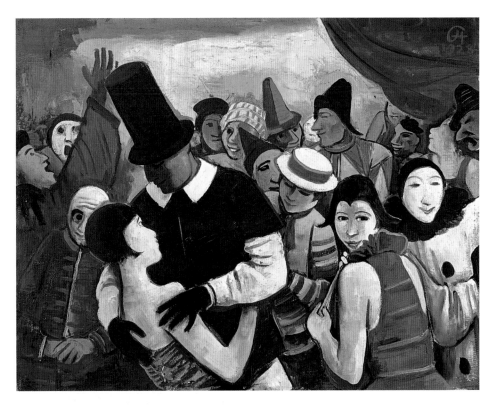

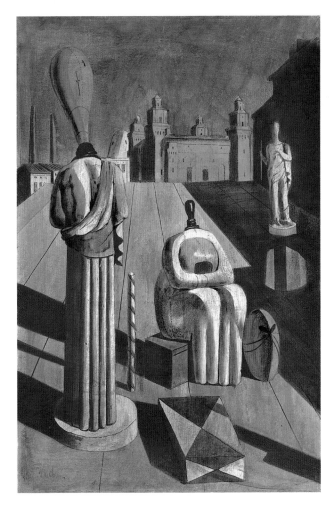

Giorgio de Chirico

Volo, Greece 1888 – Rome
1978

The Disquieting Muses, circa
1917
Gouache on paper, 94 x 62 cm
(Inventory no. 12787)
Acquired 1958

It is only on a second look that
the city landscape in which de
Chirico places his headless *muse
inquietanti* [disquieting muses]
reveals itself as strange and
disquieting. The severely
narrowing perspective of the
long boards of a stage is
truncated by the Renaissance
palace of the Este family in
Ferrara and a modern factory
building. This combination, in
itself surreal in character, forms
the background for the faceless
figures of the Muses and a
sculpture on a plinth. The
lifelessness of these mute
witnesses makes the lack of any
human presence, of any
meaning, even more apparent.

Max Ernst
Brühl 1891 – Paris 1976

Birds-Fish-Snake, 1919–20
Oil on canvas, 58 x 62.8 cm
(Inventory no. 12260)
Acquired 1956

Birds-Fish-Snake is a painting
that Max Ernst developed from
a collage in the early 1920s. The
surprising juxtaposition of
heterogeneous elements that
resulted from the collage of
unrelated pieces of paper glued
next to one another is reflected
likewise in the case of the
painted work in the absurdity of
the whole: human bodies with
birds' heads, a fish suspended in
the sky, a dog with an udder.
Apparently meaningless pictures
like this were regarded by the
Surrealists as a mirror of the
unconscious, as a reflection of
spiritual dimensions, which
remain closed to reason.

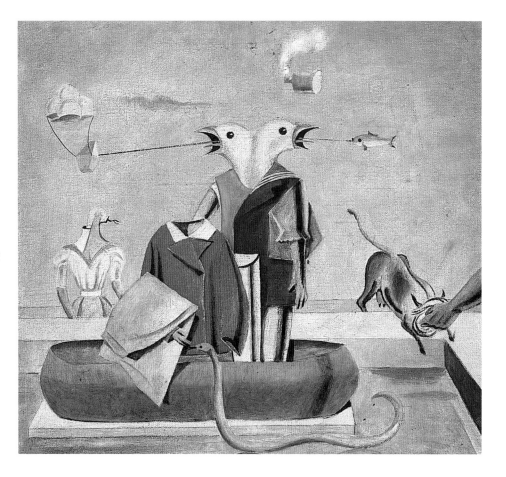

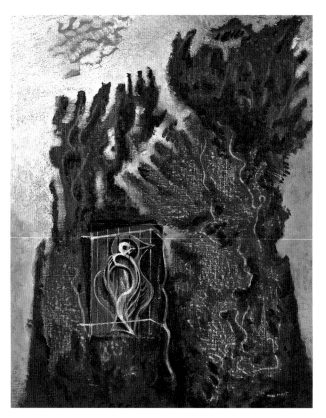

Max Ernst
Brühl 1891 – Paris 1976

Anticipation, 1926
Oil and collage on canvas,
100 x 80.5 cm
(Inventory no. 14251)
Acquired 1972

This painting – like all works by
the Surrealists – bears a title that
is of fundamental significance
for its impact on the spectator.
Here, the understanding of the
work is determined by the
opposition of optimistic
'anticipation' and the
threatening atmosphere that
surrounds the captured bird. The
bird in the cage, painted onto a
rough piece of tarred felt, is
surrounded by a dark wood and
exotic vegetation, which the
artist achieved with the help of
a printing process: chance is thus
permitted to become the point
of departure for the artistic
concept.

Max Ernst
Brühl 1891 – Paris 1976

House Angel, 1937
Oil on canvas, 54 x 74 cm
(Inventory no. L 1944)
On loan from the Theo Wormland
Foundation since 1983

House Angel reveals one of the many
facets of Max Ernst's technical
ability, which always allowed the
discovery in his work of innovative
and surprising possibilities for
imbuing the idea for a picture with
adequate expression. The spectator
stands opposite a picture that feigns
the most extreme realism, which,
however, after closer analysis of the
composition and the manner in
which it is depicted, reveals itself to
be a nightmarish illusion, with its
origins not in reality but in the
visionary inner perspective of the
artist, who is himself reacting anew
to the threat posed by the interna-
tional political situation of 1937.

Max Ernst
Brühl 1891 – Paris 1976

Totem and Taboo, 1941–42
Oil on canvas, 72 x 92 cm
(Inventory no. L 1945)
On loan from the Theo
Wormland Foundation
since 1983

The primeval landscape that
confronts us awakens
associations with prehistoric,
precivilisational ages, as well
as with an epoch in which
human life has been
sacrificed to other forces –
associations with an end of
all civilization. Max Ernst

achieved the structures we
see here by means of a
printing process depicting
mysterious, fossilised
creatures – giant birds, a
naked woman, masks, faces.
Thus a dream image was
created, the vision of an
empire driven by instinct, in
which the Superego (as
depicted by Sigmund Freud
in his work *Totem and Taboo*
– the origin of this painting's
title) has lost the power it
had once established through
totems and taboos.

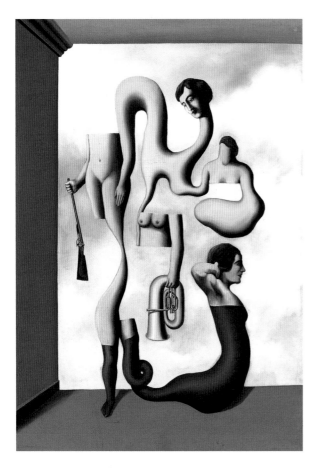

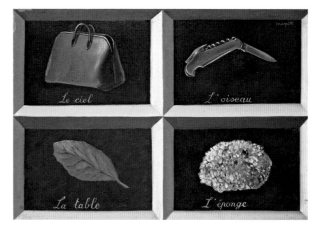

René Magritte
Lessines, Belgium 1898 –
Brussels 1967

La Clef des songes, 1930
Oil on canvas, 38 x 53 cm
(Inventory no. L 1953)
On loan from the Theo
Wormland Foundation since
1983

The series of pictures entitled *La Clef des songes* was painted between 1927 and 1930 and plays a special and at the same time central role in Magritte's oeuvre. The depiction of the mysterious, the inexpressible, of what cannot be named – which above all else characterises the artist's landscapes – is dealt with in word 'pictures' on a very much more intellectual plane, whilst Magritte playfully destroys the connection between name and object: 'No object is so linked with its name that it could not be given a different one...'

René Magritte
Lessines, Belgium 1898 –
Brussels

The Acrobat's Exercises, 1928
Oil on canvas, 116 x 80.8 cm
(Invoice no. 14252)
Acquired 1971

In *The Acrobat's Exercises* the woman's body is dismembered. It dissolves, only to reassemble itself, and, in a word, there is only one artist who could have painted this work. The scene is presented on a box-like stage with a backdrop of a blue sky strewn with clouds. In this way Magritte constructs a frame which has an effect just as absurd as the performance itself. In his usual way Magritte questions conventions in his painting and in so doing deconstructs what is self-evident, and concepts such as image and space, or writing and shape, lose their clarity.

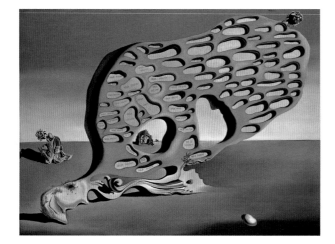

Salvador Dalí
Figueras, Spain 1904 – Figueras
1989

The Enigma of Desire – My Mother, My Mother, My Mother, 1929
Oil on canvas, 110 x 150 cm
(Inventory no. 14734)
Acquired in 1982 with the help of the Theo Wormland Foundation

If a way into Dalí's work is to be found through the realisation that the artist finds the material for his pictures in his own mental processes, and from them consciously creates paintings that appear irrational, mysterious and complex, then it is no surprise that Dalí links this image too with his self-portrait. His head is pressed to the ground by a misshapen body, which is covered with the words *ma mère*. They seem to signify the heavy burden from which the figure we see in the picture can find no release.

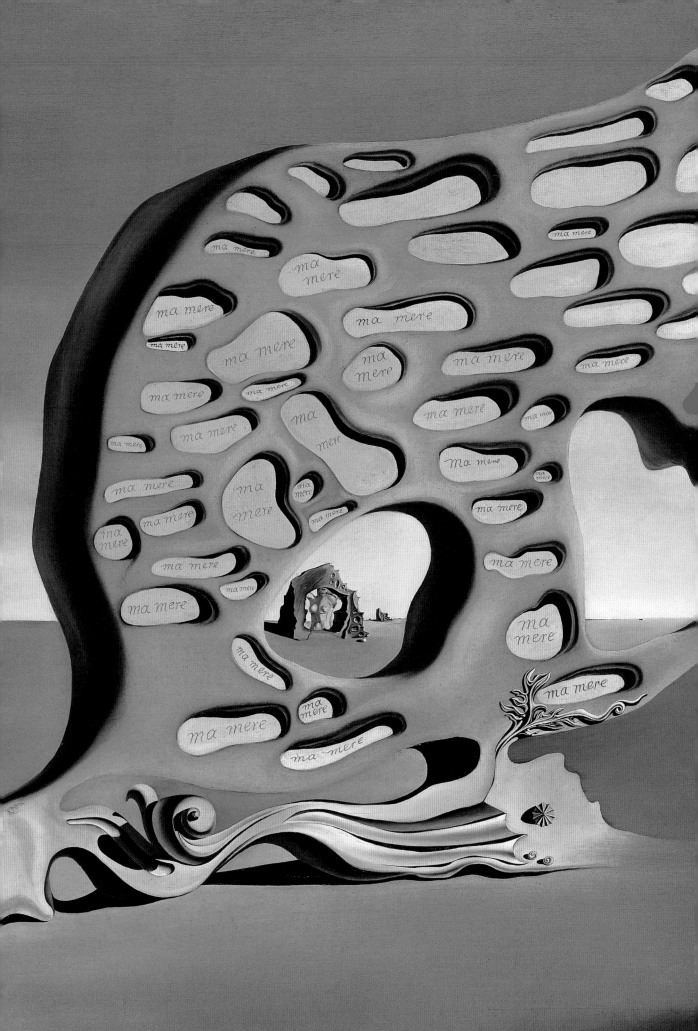

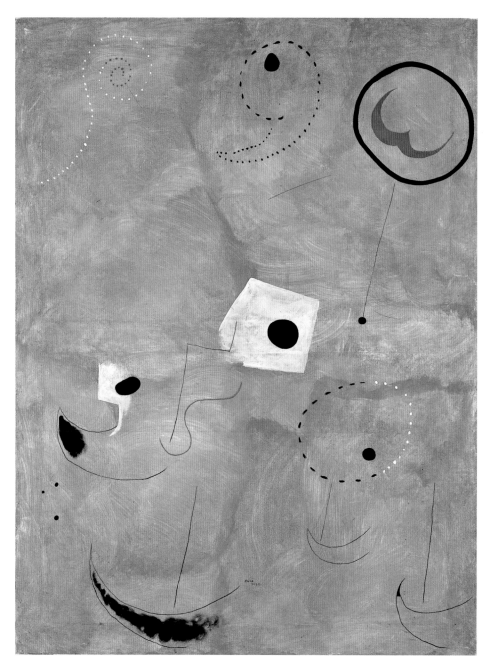

Pablo Picasso
Malaga 1881 – Mougins 1973

Woman, 1930
Oil on panel, 63.5 x 47 cm
(Inventory no. 14834)
Gift of the Theo Wormland
Foundation, 1982

A new approach can be
observed in Picasso's work from
about 1926. The balanced
beauty of his figures undergoes
a metamorphosis and develops
gradually into monstrous,
distorted, fragmented bodies
imbued with extreme aggression
and hardness. Something
demonic, untamed, dark and
disturbing haunts these paintings
and we cannot accommodate it
within our experience of reality.
Things are turned inside out,
the beautiful outer mask falls
away, so that the truth of Nature
in the surrealist sense is revealed.

Joan Miró
Montroig, near Barcelona 1893
– Palma de Mallorca 1983

Composition, 1925
Oil and tempera on canvas,
116 x 89 cm
(Inventory no. 14250)
Acquired 1971

Joan Miró expected art to be
able to express the 'fire of the
soul'. In fact one could describe
paintings executed by Miró since
the middle of the 1920s as
'dream visions', as works in
which a space is opened up for
the fusion of dream, poetry and
painting. The concrete forms of
painting dissolve into cloudy,
blue pools of colour, upon
which magical symbols hover
and unite with lines of poetry
into a dreamlike vision.

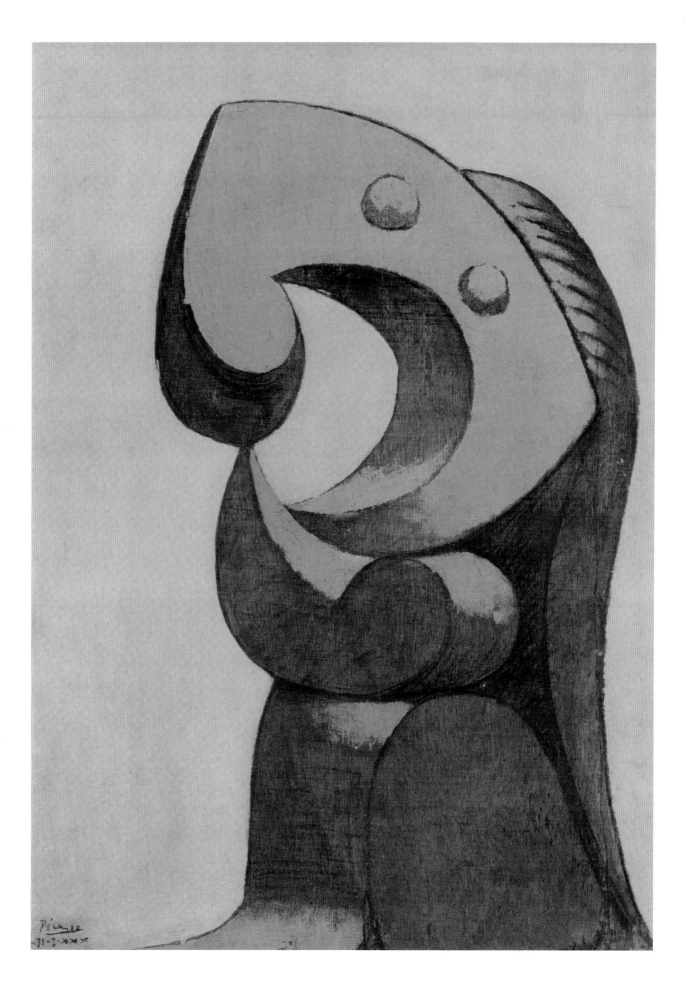

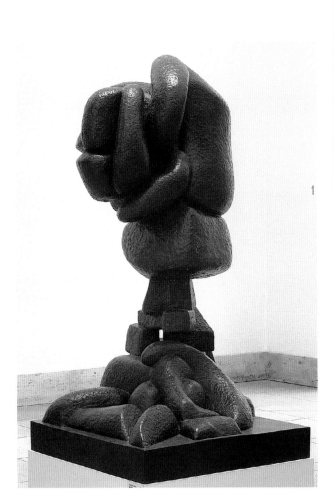

Otto Freundlich
Stolp, Pomerania 1878 –
probably in Lublin-Maidanek
concentration camp, 1943

Ascension, 1929
Bronze, 200 x 140 x 140 cm
(Inventory no. B 791)
Gift of the Theo Wormland
Foundation, 1982

Freundlich's sculpture was not
cast in bronze until 1960, from a
plaster model made in 1929; the
division of the sculpture into
three sections, mounted one
above the other, makes manifest
the concept of ascent. These
steps could be interpreted as
shoulder, neck and head, if we
compare the piece with

sculpural studies of heads by
Picasso, characterised as they are
by their dissection into the
individual anatomical elements
of the head. The sculpture may,
however, also be seen in a more
abstract manner, as an increasing
liberation of the material from
its earthbound state upwards to
a spiritualised weightlessness.

Oskar Schlemmer
Stuttgart 1888 –
Baden-Baden 1943

Dancer – Gestures, 1922–23
Oil and tempera on canvas,
200 x 130 cm
(Inventory no. 13421)
Acquired 1964

Schlemmer's *Dancer*, a painting
that is closely linked with his
work at the Bauhaus in Weimar,
opens new dimensions in the
representation of grace and
movement. The dancer's
tapering, cone-shaped limbs look
like spinning tops, powered into
swift movement. The boards of
the stage run into a perspective
and contribute to this effect of

acceleration, as do the halo of
light behind the dancer and the
vitreous blue shape to her right.
They create a magical space that
informs not only the
enchantment of the actual stage,
but also the possibility of a
spiritual element in the
movement.

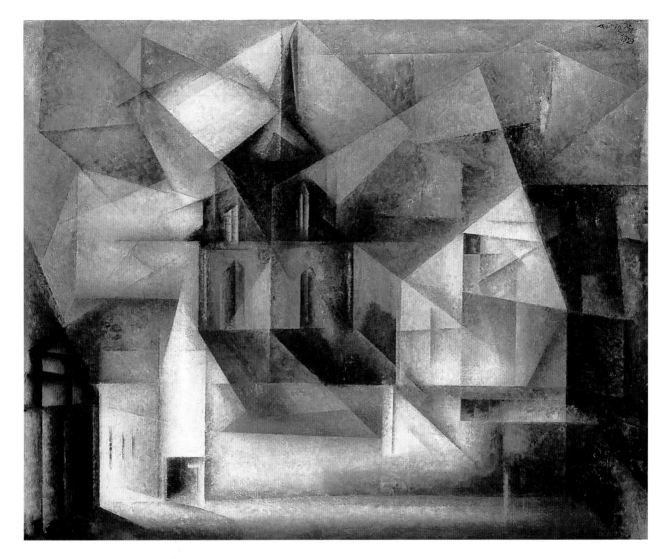

Lyonel Feininger
New York 1871 –
New York 1956

Troistedt, 1923
Oil on canvas, 80.5 x 100.5 cm
(Inventory no. L 1440)
On loan from a private
collection since 1978

Feininger painted *Troistedt*
during his time as a master at
the Bauhaus. It depicts a
Romanesque village church that
Feininger discovered during his
excursions in the region of
Weimar. The scene was first
sketched, then from this initial
'take' the artist subsequently
developed both in wood and in
paints increasingly abstract
versions of the church, which in
the clear and transparent
dissection of architecture and
space show the distinct
influence of Feininger's
acceptance of Robert
Delaunay's Orphist–Cubist style.

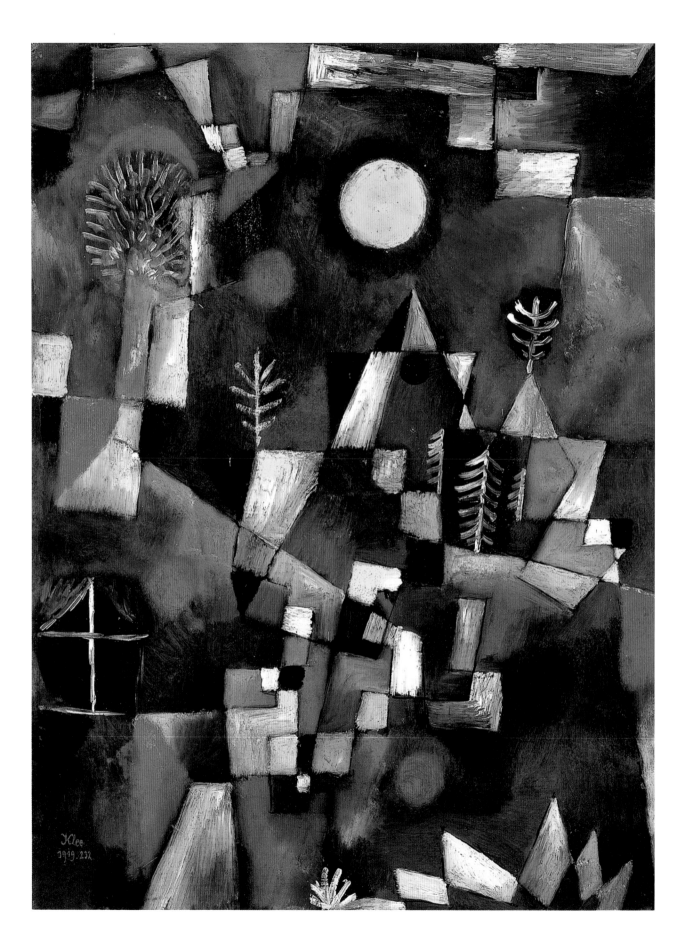

Paul Klee

Münchenbuchsee, near Bern
1879 – Muralto, near Locarno
1940

Vollmond [Full Moon], 1919
Oil on paper on cardboard,
50.4 x 38.1/38.5 cm
(Inventory no. 15249)
Acquired 1991

Vollmond was painted after the
First World War and shows the
influence of Cubism in its
bright, mosaic-like structure.
The bewitched nature of the
painting, far removed from
reality, leads the spectator to see
it as the artistic consequence of

the tragic end of the war; in
terms of Klee's development it
signalled the breakthrough to
abstraction: 'The more
frightening this world becomes
(and exactly as it is today), the
more art moves towards the
abstract; whilst a happy world,

on the other hand, would
produce art of a more material
character.' This was the artist's
summing up of the situation in
1914 and he thereby
characterises abstraction in art as
a means of salvation.

Paul Klee

Münchenbuchsee, near Bern
1879 – Muralto, near Locarno
1940

*The Dance of the Grieving Child
II*, 1922
Traces of oil and oil paint on a
chalk primer on gauze with
pieces of canvas stuck on, with
watercolour and pen above and
below, on card, 33.8 x 23 cm
(Inventory no. 14229)
The Woty and Theodor Werner
bequest, 1971

The movement of the grieving
child seems less like a dance
than a striving for equilibrium.
An outsized head, leaning
heavily backwards, sits on a frail
body; the child is trying to
balance this weight with its
outstretched arms. Klee's artistic
interest in the effect of gravity
has its roots in his repeatedly
formulated preoccupation with
tragedy as being indissolubly
bound up with human existence
– a tragedy that is born of the
discrepancy between physical
attachment to earth and spiritual
freedom.

Paul Klee

Münchenbuchsee, near Bern
1879 – Muralto, near Locarno
1940

Plants Growing at Night, 1922
Oil paint on card,
47.3 x 33.9/34.1 cm
(Inventory no. 15250)
Acquired in 1991 with the help
of the Kulturstiftung der Länder
(the regional foundation for
culture)

Klee's *Plants Growing at Night* is
an allegory of the growth of
vegetation in Nature in which
the image is formed of fragile

towers constructed of geometric
shapes. The tiered movement
from below upwards
corresponds to a progression
from dark to light, thus creating
the impression of geometrically
ordered structures, which grow
secretly from uncertain depths
towards the daylight: gradually
the different-shaped plants move
towards the light in all their
individuality. The composition –
abstract yet inspired by natural
laws – is closely linked to Klee's
teaching at the Bauhaus about
colour relationships and their
laws.

Paul Klee
Münchenbuchsee, near Bern
1879 – Muralto, near Locarno
1940

The Limits of Understanding, 1927
Pencil, oil and watercolour on
primed canvas, original frame,
56.2 x 41.5 cm
(Inventory no. 14234)
The Woty and Theodor Werner
bequest, 1971

In confronting perfection, peace
and harmony, formed from a
circular network of the finest
lines, Klee creates a comparison
for the opposition of reason and
emotion. He takes as his theme
the conflict between the limits
of human existence and the
infinity of man's imagination –
the irreconcilability of reality
and dream. This Romantic
concept links the artist
stylistically to the ironic
reference to the realism and
rationality of constructivism,
which gained a foothold at the
Bauhaus but to which Klee was
critically opposed.

Paul Klee
Münchenbuchsee, near Bern
1879 – Muralto, near Locarno
1940

Light and Various Other Things,
1931
Watercolour, pen and pencil on
a white oil varnish ground on
canvas, mounted on stretchers,
95 x 97 cm
(Inventory no. 14070)
Acquired 1968 with the help of
PIN, the Friends of the
Pinakothek der Moderne

The pointilliste series of pictures
that Klee started at the very
beginning of his time as
professor at the Düsseldorf
Academy, and which reaches its
climax with *Light and Various
Other Things*, can be understood
as his homage to pure painting.
Seurat applied colour in points,
so that these points mingle in
the eye of the beholder to
form discernible objects once
more. Klee, on the other hand,
detaches himself from any
claim to an illustrative function.
His points of colour are
enough in themselves and
produce a picture of pure
'chords' of colour.

László Moholy-Nagy
Bácsborsod, Hungary 1895 –
Chicago 1946

Composition K IV, 1922
Oil on canvas, 129 x 99 cm
(Inventory no. 13060)
Acquired 1960

Moholy-Nagy's abstractionism is
rooted in constructivism, which,
because of its origins in a
revolutionary movement whose
aim was social change, is strongly
marked by creative and functional
ideas. Moholy-Nagy, who from
1923 directed the painting school
at the Bauhaus in Dessau, made
use of the same vocabulary of
geometrical forms, and developed
the same eagerness in
experimentation in the fields of
light and transparency that
marked his practical designs, and
thus achieved compositions of
enormous strength and balance.

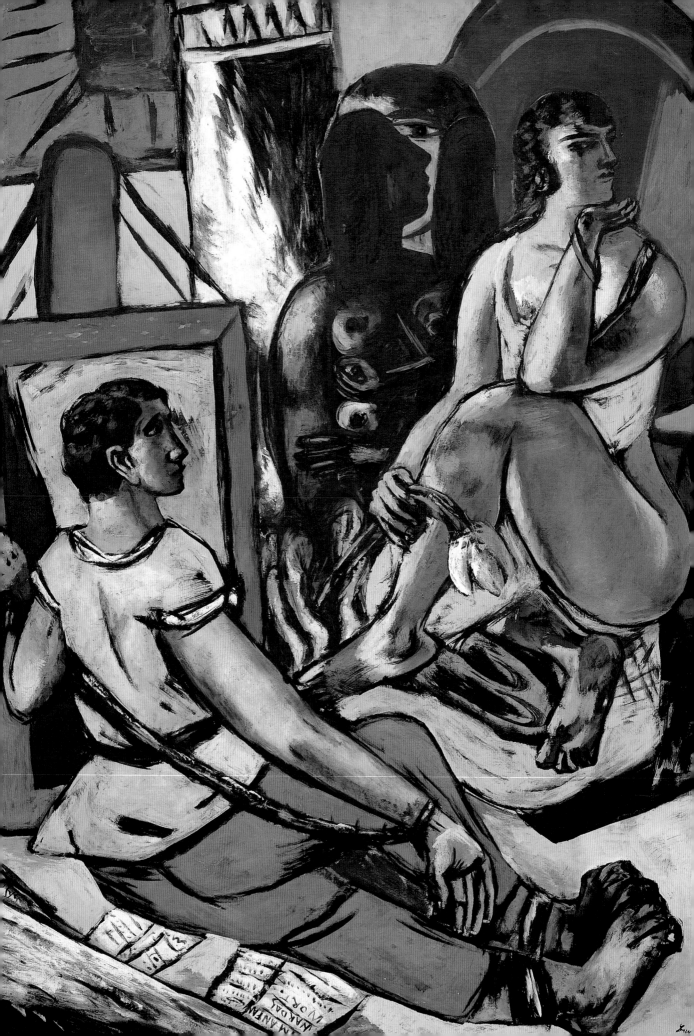

The Second World War and the Years that Followed

Picasso, Beckmann, European Post-War Abstractionism, Abstract Expressionism, Tachism, Cobra

The Fascists' seizure of power in Germany and finally across great tracts of Europe signified a turning point for many artists of the avant-garde movement. They were forced to emigrate and to go into hiding; they also had to step back from the revolutionary claims they had made in the movement's early years. It was a time of far-reaching change that affected the definition of art. The consequence was that art was divided into two categories, 'official' and 'degenerate', and this frequently resulted in painful intervention in the personal lives of the individual artists themselves.

Max Beckmann was dismissed by the Nazis from his post at the Frankfurt School of Art in 1933, and spent the years from 1937 until 1946 as a refugee in Holland. His reaction to these insecure and frightening times was his huge triptychs, which he produced during the 1930s; these paintings perceive fear and hopelessness through a barely decipherable

universe by means of a graphic return to a form of medieval sacred art. This is the case not least for *The Temptation of St Antony*, in the Pinakothek der Moderne. It is a monumental work that formulates images of horror in a surreal atmosphere in a stylistic return to the vocabulary of the antique or to Picasso's paintings of those years.

Before the outbreak of the Second World War, Picasso himself had already developed a style that persisted in his work of the war years and which reached its climax in his famous painting of 1937, *Guernica*, the expression of his reaction to the bombing of a Spanish village by the Fascists. But even his series of portraits of his lover Dora Maar is marked by brooding colour and black outlines, as well as by a narrow boxed space in which the model, painted in garish colours, appears to be hopelessly trapped.

We are confronted with unexpected violence in the paintings of Francis Bacon, who combines highly

Max Beckmann,
Temptation (The Temptation of St Antony)
(Detail from page 62)

sensual figurative art with an exceptionally elegant and purist style. His triptych of 1965, *Crucifixion*, juxtaposes three scenes of violence that draw clear references to Fascism. In contrast, the *Crucifixion* of Antonio Saura, painted in 1959, is more abstract, and conveys the subjective feelings of the artist by means of a pronounced, highly gestured style of painting. Here, too, a figurative style is retained, but it can only be interpreted through its alienation.

The same is true for the important sculptures of the post-war period, represented in the collection of the Pinakothek der Moderne by Henry Moore and Marino Marini. Moore's *Falling Warrior* is like an echo of Lehmbruck's *Fallen Man*. In both cases abstractionism illustrates the artist's allegorical statement that may be understood as an anti-heroic criticism of war.

The two decades following the Second World War are distinguished in art by divergent stances. On the one hand a strong, expressive, figurative direction in art, which is technically based on Surrealism, Expressionism and Cubism, draws a dramatic and pessimistic picture of reality; on the other hand there is a movement towards abstract art, which in its subjective character and the pure formality of its certainty seeks a spiritual escape from the trauma of the experiences of war. A controversial and often polemical debate flared between these two positions in Germany in the years following the war, and quite naturally 'abstract expressionism' emerged in America, offering the foundation for the many artistic movements in America and post-war Europe.

However, Fritz Winter, Willi Baumeister and Ernst Wilhelm Nay, to name but the most important advocates of Abstractionsim in Germany, followed neither this contemporary American abstractionist current nor Tachism – represented in the collection here by Wols's important work *Composition*; they based their painting rather on the representation of 'the

spiritual in art', thus harking back to the tradition of 'Der Blaue Reiter'. They understood their abstract compositions clearly as images of an imaginary, inner world, in which structures can be perceived that would normally remain concealed beneath the surface of appearances.

The task of the Romantic ideal of the artist, which lies behind this concept, was fundamental to the abstract movement that was developing in parallel in America. The artist's creation here seems to free itself from its creator – such is the unstoppable energy of the broad brush strokes across the canvas, for instance in de Kooning's *Detour* or Franz Klines's *New Year Wall* – and points simultaneously to something beyond the artist himself. In contrast, Jasper Johns suggests an option in the choice of themes and style of his painting *Arrive/Depart*: he applies precise, limited shapes and emotionally charged brush stokes side by side on the canvas, which in addition admits fragments of reality. Reality plays a constituent role in the collage that the artist more or less arbitrarily combines in the overall composition. This is also Robert Rauschenberg's technique in his *Composition with Football Players* of 1962, whilst Robert Motherwell takes advantage of the enormous freedom of composition acquired largely through these new approaches in order to achieve the lyrical effect of his giant painted collages.

Cy Twombly must be regarded as an exception within the 'New York School': he emphasises the surrealist roots of this movement while at the same time developing his work from the inquisitive yet seismographic drawn line. His painting combines an intuition for his subject with freedom of line and may be considered as an American–European movement – the more so because the artist, who has lived in Europe since the 1950s, makes frequent reference to evidence of ancient civilisation and includes it fragmentarily in his work.

The art of the 'Cobra' group, of which Asger Jorn may be considered a protagonist, reveals itself to be inspired as much through figurative or representational art as through abstract art. His magnificently coloured paintings return on the one hand to a German expressionist tradition. This vitality of colour and line, however, contrasts with a complexity and sensitivity in his art that seem to be inspired by the subtle paintings of Wols and the originality of the French 'Art brut'. Both Jorn, in his *Parodontosis of the Eagle*, one of the group's principal works, and Karel Appel integrate the figurative into their paintings – vaguely hinted-at motifs that can only be identified amid the swirl of the colour on a second inspection.

Both Antoni Tàpies and Emil Schumacher open up new dimensions of expression in the field of a materially related abstractionism, each in his own way. Whilst Schumacher makes painting graphic by means of materials applied to the canvas, a fabric that slowly builds up and forms out of the painting – as his *Harun* of 1979, now in the Pinakothek der Moderne, makes clear – Tàpies's work has a heavier and more aggressive effect. In his case the plastic mass is loaded straight on to the canvas, and even incorporates the application of whole objects, planks, or sheets of metal. There is a definite liberation here of the concept of art from its bond with the idea of the representation of an image on the canvas, which is now destroyed in the artistic creative process.

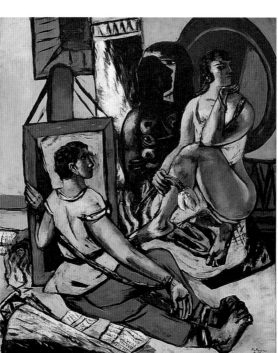
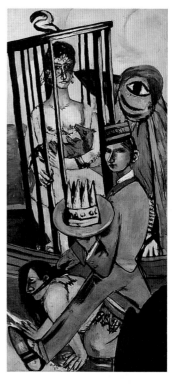

Max Beckmann
Leipzig 1884 – New York 1950

Temptation (The Temptation of St Antony), 1936–37
Oil on canvas, central picture
200 x 170 cm; each side panel
215 x 100 cm
(Inventory nos 14486–14488)
Acquired 1977

The second of the nine triptychs that Beckmann painted was executed in Berlin in 1937, the year of the 'Degenerate Art' exhibition, and indeed the reflection of Beckmann's situation during the Fascist period intrudes here. The subtitle of the work – *The Temptation of St Antony* – which refers to Beckmann's engagement with Flaubert's theories, is a hint that what we have before us is not about a specific incident. Rather, the figures that Beckmann depicts are placed in a symbolic connection that has as its background the psychic dimension of the roles of victim and perpetrator.

Max Beckmann
Leipzig 1884 – New York 1950

Self-Portrait, 1944
Oil on canvas, 95 x 60 cm
(Inventory no. 10974)
Acquired 1949

It is a stern and unfamiliar Beckmann who faces the spectator in his self-portrait of 1944, painted during the artist's period of exile in Holland. If we consider the extreme conditions under which the artist lived and worked in Amsterdam, the normality of the black suit he is wearing seems to be some sort of disguise. His shaded eyes and his arm, which seems to be extended like a barrier between the subject and the spectator, seem to represent grief and isolation. Behind this mask, conventional in its composition and expression, the artist seems to hide the subjective tragedy of his personal circumstances.

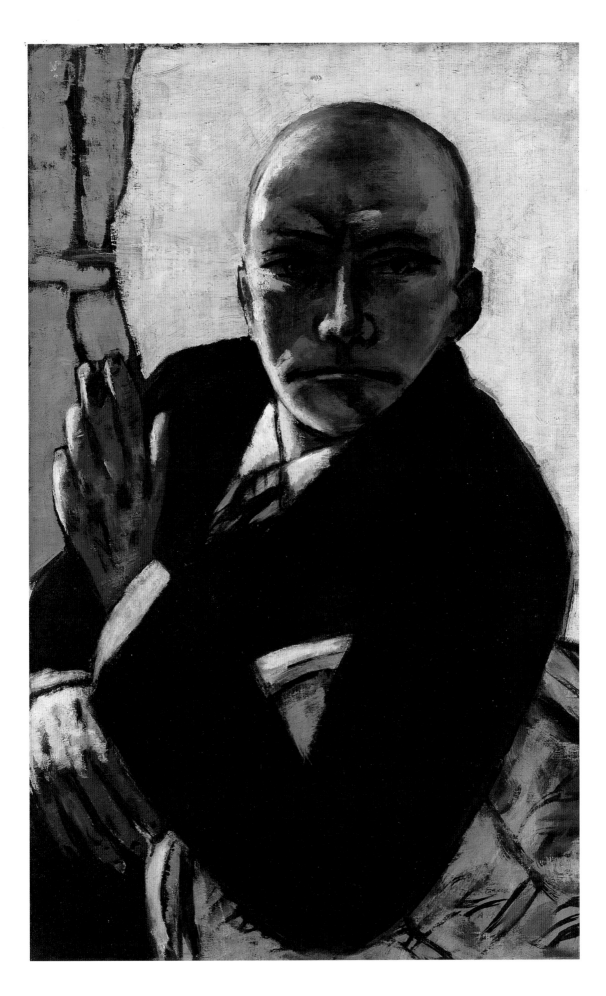

Max Beckmann
Leipzig 1884 – New York 1950

*Woman with a Mandolin in Yellow
and Red*, 1950
Oil on canvas, 92 x 140 cm
(Inventory no. 15253)
Acquired 1991

If Beckmann's painting seems in
the sensual presence of its subject
to be related to Picasso's hymns to
female beauty, then its balanced
composition, decorative, colourful
and ornamental design remind one
of Matisse. Yet Beckmann has
created a picture that in its
representation of the woman is
characteristic of his own view of
the theme. The rounded beauty of
the young woman's body does not
appear to be relaxed; on the
contrary, her reaction to the
mandolin, which stretches
aggressively towards her averted
face in the tradition of images of
'Leda and the Swan', seems to be
one of utter repulsion.

Pablo Picasso
Malaga 1881 – Mougins 1973

Woman Seated, 1941
Oil on canvas, 99.8 x 80.5 cm
(Inventory no. 14240)
The Woty and Theodor Werner
bequest, 1971

In the early 1940s Picasso painted a
series of portraits of Dora Maar, his
lover at that time, and herself an
artist, which show this headstrong
young woman always in the same
chair in the artist's studio. While
some of these portraits are more like
sketches or have only partially
worked detail, the complete nature
of this one implies that it may well
have been the final study in the
series. The distortions and
abstractions to which her image is
subjected lend Dora Maar a
grotesque appearance. Cubism
dictates the formal effects here;
Picasso's adoption of Surrealism
provides the background.

Henry Moore
Castleford 1898 –
Much Hadham 1986

Falling Warrior, 1956–57
Bronze, 47.5 x 150 x 78 cm;
height of plinth 27 cm
(Inventory no. B 380)
Acquired 1961

Like Lehmbruck with his *Fallen Man*, Henry Moore portrays here the concept of the doomed hero, whose fall contains within it a new pacifist ideal. The blank anonymity of the strongly abstract head of the warrior forms a stark contrast with the naturalistically formed feet and legs. The warrior's puny arms are incapable of pulling him upright again: as with his whole body, they no longer have a natural function, but are reduced to symbols.

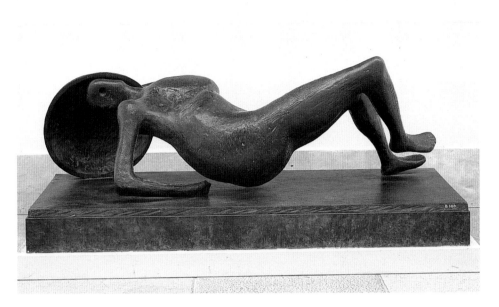

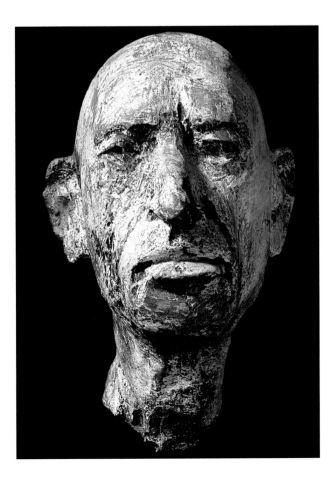

Marino Marini
Pistoia 1901 – Viareggio 1980

Portrait of Igor Stravinksy, 1951
Bronze, limewashed white,
27.5 x 18 x 22 cm
(Inventory no. B 697)
Donated by Marino Marini
Foundation, 1976

In this portrait of the composer Igor Stravinsky, with whom Marino Marini felt a special bond, it becomes clear that in portraiture too, despite the completely individual nature of the genre, it was important for the artist to work out the concept of the eternal and a universal validity. The sensitivity of the handling of the surface, heightened with white limewash, outlines powerfully the features of Stravinsky's physiognomy. It is no fleeting impression that is conveyed by this bronze; rather it distinguishes the immortality of the personality, and in this way elevates it above the purely accidental.

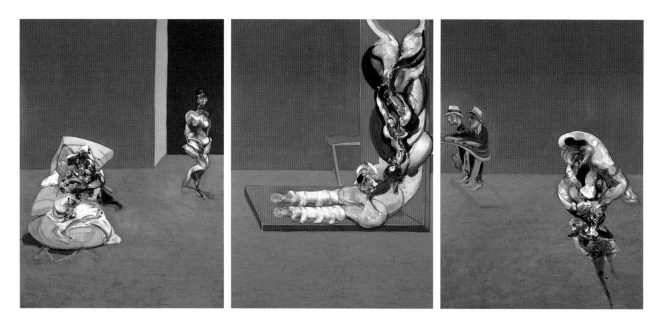

Francis Bacon
Dublin 1909 – Madrid 1992

Crucifixion, 1965
Oil on canvas, each
198 x 147 cm
(Inventory nos GV 1–3)
On loan from the
Museumsstiftung [Museums
Foundation] since 1967

As expressed in the work's
title, a sacral dimension, which
appears to super-elevate the
scenes of violence that Bacon
depicts, is concentrated in the
form of a triptych. With
particular sensuality, and across
three canvases, violence unfolds
as the theme of this artist, who
appraises the human body as a
'potential corpse'. The abused
body – forsaken, tortured,
humiliated – induces in the
painter an artistic virtuosity: it
is not just that destruction and
suffering seem palpable here,
they are translated into a kind
of beauty. In contrast to this
emotionally driven, gestured
manner of painting, the stage-
like background remains
abstract. The intimated
spatiality dissolves in the cool
elegance of the colours and
becomes the indifferent,
aesthetic foil of events.

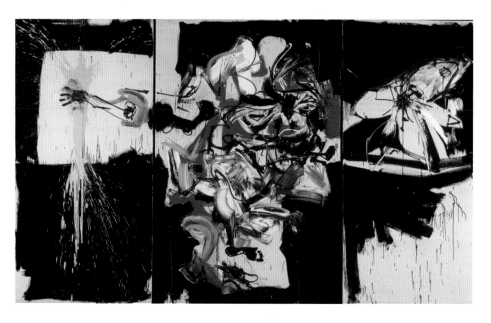

Antonio Saura
Huesca 1930 – Cuenca 1998

Crucifixion, 1959
Oil on canvas, triptych, central
panel 195.5 x 129 cm; side
panels each 195.5 x 96.5 cm
(Inventory no. L 2368)
On loan from Otto van de Loo
since 2001

Saura's *Crucifixion* goes far
beyond the biblical theme: 'It is
true I have reflected my own
situation in the image of the
crucified Christ,' the artist said,
'I am one of those people who
stand alone in a threatening
universe and can do no more
than cry out. I am concerned
only with the human tragedy
and not with that of a God who
was nailed senseless to a cross,
and my image could
symbolically represent this

tragedy of our time…' Saura
translates the idea of loneliness
and of man's abandonment by
God – a basic concept of the
Existentialism of the 1950s –
into a highly dramatic art form,
into an image that frees itself
from absolute darkness only to
express pain, suffering and
torture in a style that borders on
violence.

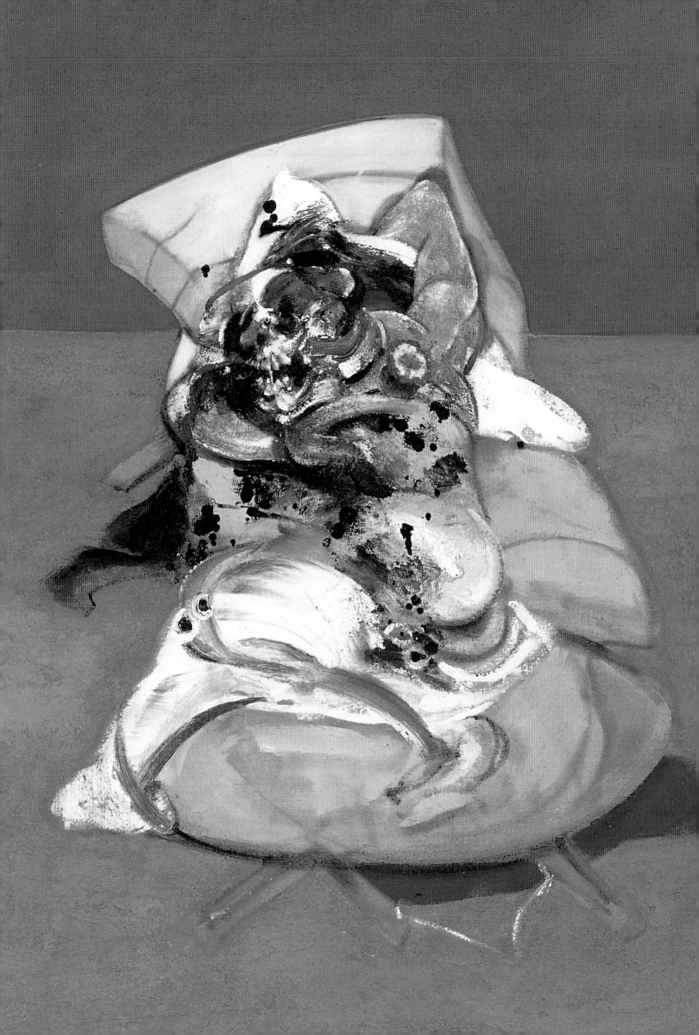

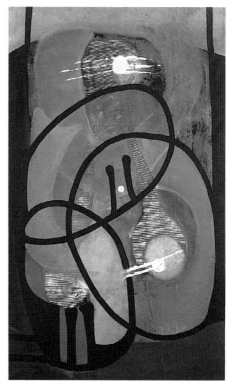

Heimrad Prem
Roding, Oberpfalz 1934 –
Munich 1978

Crucifixion, 1961
Oil on canvas, 100 x 130 cm
(Inventory no. 15204)
Acquired 1990

It is the drama of the artist's
expressive–aggressive style and
the contrast between intense
darkness and areas of strong
colour alone that first of all
suggest a reference to the title of
this painting, *Crucifixion*.
Heimrad Prem renews in his
work the tradition of German
Expressionism from the
proximity to the 'Cobra'
movement, and linked the
painting process closely to
psychic processes; he conveys
the idea of pain, suffering and
violence through his
emotionally determined artistic
style, which conceals shapes of
objects – only gradually
identifiable – chiefly in the
chaos of the composition. A
dragon's head, a chain, iron bars
and spearheads emerge slowly
from the tangle of colours, but
the painting's intimation of a
latent threat nevertheless
remains.

Fritz Winter
Altenbögge, near Dortmund
1905 – Diessen, near Ammersee
1976

Linear Composition, 1934
Oil on paper and canvas,
245.4 x 248.5 cm
(Inventory no. 13680)
Acquired 1965

Linear Composition is one of the
largest and most important
paintings by this artist, who
turned to Abstractionism at the
beginning of the 1930s. Having
completed his study at the
Bauhaus, Fritz Winter worked
for a few months together with
the sculptor Naum Gabo, whose
sculptures, defined by light and
movement, compelled him
towards a new manner of
painting; his pictures now
appear to be determined by a
particular, transcendent light,
and seem to open up
perspectives and cosmic spaces
where the planets pursue their
courses.

Wols
(Alfred Otto Wolfgang Schulze)
Berlin 1913 – Paris 1951

Composition, 1946
Oil on canvas, 53.8 x 65 cm
(Inventory no. 13178)
Acquired 1962

During the course of the 1940s
the works of the photographer
and painter Wols, which were
clearly influenced by Surrealism,
disintegrate into abstract
'scriptograms', into extremely
intricate and complex
compositions that appear to
consist of layered structures. In
his *Composition* of 1946 a web of
scribbled and scratched lines is
laid onto a speckled colour base,
on which several suns lead the
association with a landscape
painting towards the absurd. The
theme of disintegration and
decay, which always preoccupied
Wols in both his photographic
and his graphic work, seems to
haunt his later paintings too and
to determine their structure and
technical execution.

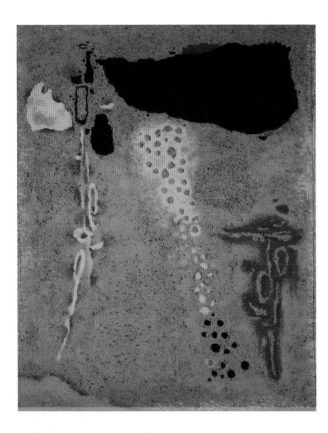

Willi Baumeister

Stuttgart 1889 – Stuttgart 1955

Safer avec des points, 1954
Oil and sand on cartridge paper
on canvas, 100.3 x 81.2 cm
(Inventory no. WAF PF 67)
On loan from the Wittelsbacher
Ausgleichsfonds [the Wittelsbach
settlement fund] since 1985
The Collection of Prince Franz
of Bavaria

Willi Baumeister, an important
integrational figure for abstract
art in Germany after the Second
World War, located his work
thematically from 1945 onwards
in an area that had no point of
contact with contemporary
world events. *Safer avec des points*
is likewise a painting that
appears to have been executed a
long time ago. Indecipherable
signs and symbols line up one
next to the other as if in a cave
painting dominated by a huge
black shape that hovers
menacingly over the
composition. The rough but
splendid effect of the
background of the painting
emphasises the impression of a
weather-beaten wall and thus
the autonomy of a work that
seems to have its origin in its
own spiritual space, independent
of time and reality.

Ernst Wilhelm Nay

Berlin 1902 – Cologne 1968

Rhythms and Quantums, 1964
Oil on canvas, 200 x 160 cm
(Inventory no. L 1974)
On loan from the Theo Wormland
Foundation since 1983

Ernst Wilhelm Nay's 'disc' pictures
date from the mid-1950s onwards
and may be seen as a natural
progression of the abstract
compositions that the artist created
immediately after the war. Nay's
interest is now focused on colour and
its application. The brush strokes that
break up the colourful circles in
Rhythms and Quantums recall
American Abstract Expressionist art,
while the exciting harmony of the
colours appears to hark back to
Orphism's complementary colour
contrasts. Nay's disc pictures, with
their contrast-rich and atmospheric
use of colour, assume a completely
new and original stance within this
tradition.

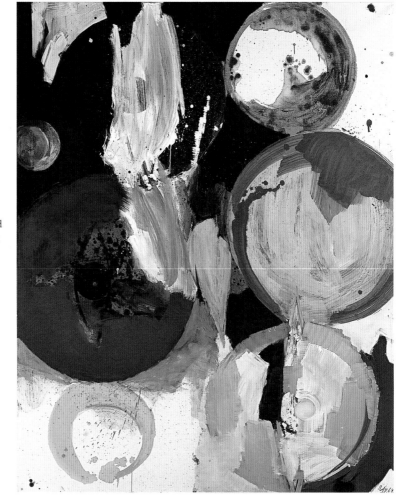

Rupprecht Geiger
Munich 1908

2 x Red, 1965
Oil on canvas, 202.3 x 223.3 cm
(Inventory no. L 1797)
On loan from the Theo
Wormland Foundation since
1980

In Rupprecht Geiger's work
colour detaches itself from each
shape as an autonomous value –
it appears to spread itself
independently across the canvas.
In the painting *2 x Red*, a dark
claret falls like a heavy curtain
from the upper edge of the
picture and meets a narrow
band of pink of a much more
solid effect. A fine spray of
coloured particles at the point
of impact of the two colour
tones resembles whirling dust.
In his understanding of painting
and colour Geiger is close to
Yves Klein or Mark Rothko,
but his link to the tradition of
'Der Blaue Reiter', to the
'spiritual in art' is a determining
factor in the separation of his
colours from form at last finding
a definition.

Asger Jorn
Vejrum 1914 – Aarhus 1973

Albisola, 1955
Oil on canvas, 68 x 55 cm
(Inventory no. 15535)
The gift of Otto van de Loo,
1987

Albisola reflects the experiences
of Asger Jorn in the medium of
ceramics, with which he was
occupied in 1954 in the ceramic
workshops of Albisola. Behind its
surface, reminiscent of
enamelling technique and of
viscous, dripping colour
application, his painting
nevertheless conveys an
expressive, gestured style; this
creates facial features that
gradually seem to come to life.
In the context of the art of the
'Cobra' group, founded in Paris
in 1948 and of which Asger Jorn
was a member, this abstract face
shows itself to be liberated from
traditions and conventions.

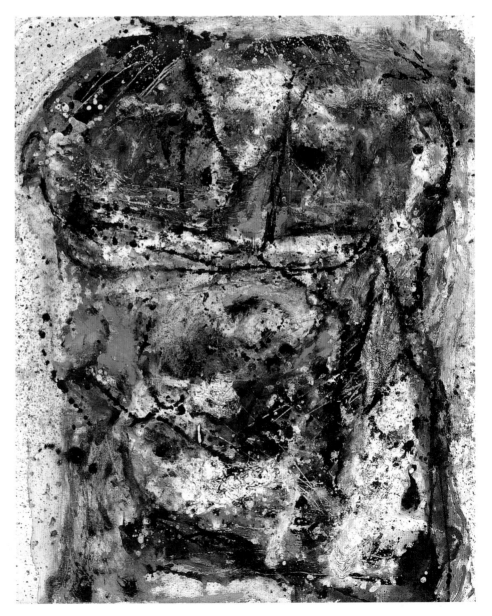

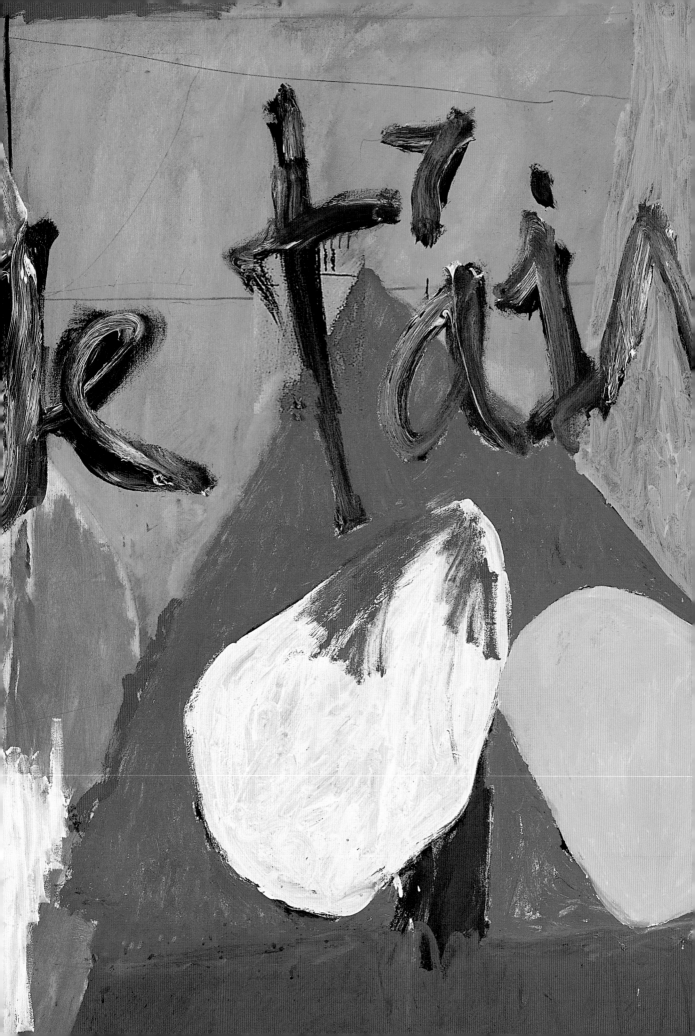

Asger Jorn
Vejrum 1914 – Aarhus 1973

Parodontosis of the Eagle, 1958
Oil on canvas, 80 x 100 cm
(Inventory no. 15208)
Acquired 1990

Parodontosis of the Eagle was
painted during a crisis in Asger
Jorn's life, and the artist allowed
his own feeling of weakness and
sorrow to spill over into his
work. The composition is
determined by the central,
powerless brown form, whose
former power and strength are

visible in the dark heaviness of
the work. Above it rise blue
faces with goblin features,
which, even though not in
themselves bright belong to a
brighter and lighter realm that
surrounds the darkness. The
firm, pastose application of
colour to the centre of the
picture thins towards the edges
of the composition, almost to
transparency, so that even on the
level of its artistic translation,
the complexity of the artist's
emotional state, which is the
origin of this composition,
finds expression.

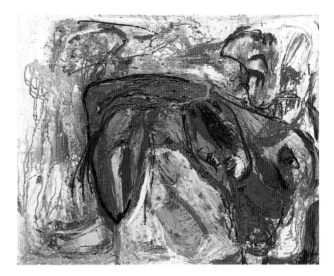

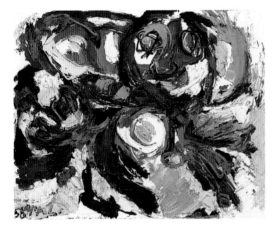

Karel Appel
Amsterdam 1921

Personnage et soleils, 1958
Oil on canvas, 81.3 x 100 cm
(Inventory no. 15326)
Acquired 1992

Karel Appel's composition
reflects not only a primeval
aggression and directness but
also a confrontation with the art
of 'Abstract Expressionism',
which left a definite impression
on the artist's work following a

trip to America. The emotion-
laden application of colour that
allows the artist to duplicate his
brush strokes – which are out of
all rational control – makes this
influence vividly apparent and
forces it to dominate the picture
so that the plane of principal
representation, where two faces
can be identified, has to recede
into the background.

Robert Motherwell
Aberdeen, Washington 1915 –
Aberdeen, Washington 1991

Je t'aime, 1955
Oil on canvas, 177 x 255 cm
(Inventory no. 14836)
Acquired 1983

The bright and cheerful *Je
t'aime* is not only Robert
Motherwell's counter-project to
the elegiac *Laments for the
Spanish Republic*; with this
composition in warm and light-
filled colours he also formulated
a homage to the French artists
of the first half of the twentieth
century – the suggestion of the
easel serving as a reminder of
the still-lifes of Braque and Gris.
The large script that appears to
hover over the painted surface,
the coloured shapes, which
likewise detach themselves from

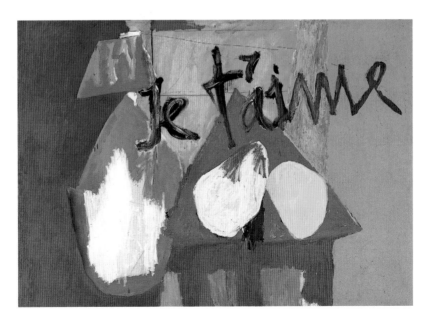

the context of the composition
and maintain their autonomy,
and the background of the
painting, covered with broad

brush strokes of colour, are
nevertheless evocative of the
ideas of 'Abstract Expressionism'
– ideas that transcend the

boundaries of the traditional
concept of the picture.

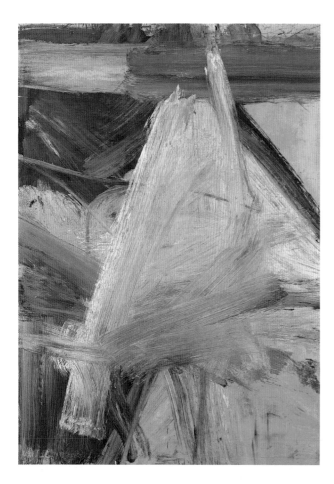

Willem de Kooning
Rotterdam 1904 –
New York 1997

Detour, 1958
Oil on paper on canvas, 150 x
108 cm
(Inventory no. 14614, GV 57)
Acquired in 1979 with the aid of
PIN, the Friends of the
Pinakothek der Moderne

Dutch by birth, Willem de
Kooning was resident in the USA
from 1926, and is one of the main
advocates of American Abstract
Expressionism. His abstract
compositions are defined by
broad, spontaneous brushwork and
permit interpretations of their
content or the recognition of a
conscious arrangement in the
composition, only as vague associ-
ations, both from the artist's per-
spective and from that of the
spectator. The painting itself is
decisive: it seems to separate itself
from its creator and covers the
canvas with broad brush strokes,
extending its boundaries to infinity.

Franz Kline
Wilkes-Barre 1910 –
New York 1962

New Year Wall: Night, 1960
Oil on board, 304 x 488 cm
(Inventory no. 14437, GV 19)
Acquired in 1975 with the help
of PIN, Friends of the
Pinakothek der Moderne

Franz Kline's *New Year Wall:
Night* is determined by huge
artistic gestures, by a layer of
paint that can barely be called
black, which threatens to shroud
the canvas like nightfall or a
barrier that is becoming denser.
These associations developed
from the picture's title are,
though, only weak images for
what is happening on the
canvas. Painting is here one and
the same thing as theatre; it
appears as an unstoppable
dynamic process that tears the

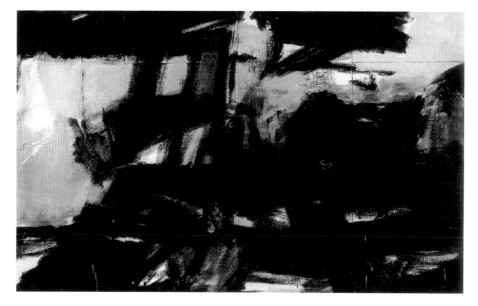

artist along with it and which
breaks through not only the
boundaries of a traditional
definition of painting but
indeed the canvas itself.

Robert Rauschenberg
Port Arthur, Texas 1925

Composition with Football Players,
1962
Oil and screen print on canvas,
153.8 x 91.4 cm
(Inventory no. 14464)
Klaus Gebhard bequest, 1976

Rauschenberg's art is first and
foremost about incorporating
reality as directly as possible into
his works, and the picture
Composition with Football Players
seeks to establish a compromise
between 'pure' abstract painting
and reality, two elements that
the artist combines particularly
by limiting his palette to tones
of grey and black. With the help
of photographs imposed on the
canvas by the screen-printing
process, various material
structures, terse symbols and
broad sweeps of paint together
create one image in which the
artist's subjective idiom
combines with an apparently
random selection of images
drawn from daily reality.

Jasper Johns
Allendale, South Carolina 1930

Arrive/Depart, 1963
Oil on canvas, 173 x 131 cm
(Inventory no. 14465)
The bequest of Klaus Gebhard,
1976

Starting with the shadow of a
skull in the bottom right-hand
corner of the painting, this
otherwise abstract composition
by Jasper Johns may be read as a
modern vanity image of art, in
which the artist tests many of
the possibilities of painting that
call each other into question.
He applies free, loose brush
strokes to the canvas in bright,
richly contrasting tones; he then
juxtaposes a precise, limited
rectangle of colour, copies
handwriting onto the picture, or
projects a hand-print on to the
canvas. What is painting – does
it still possess the power of
delusion, the ability to delight
us, to interpret the world for us?

Emilio Vedova
Venedig 1919

Situations Collide, 1958
Tempera on canvas,
145 x 195 cm
(Inventory no. 14624)
Acquired 1979

The orientation towards
American 'action painting',
which can be seen in Vedova's
work from the beginning of the
1950s, is immediately evident in
this picture. The brush strokes
are applied to the canvas with
apparently unlimited energy and
spontaneity that create the
impression of unstoppable
movement within the
composition. The polychrome
painting evolves from the centre
outwards to the edges of the
picture and threatens to extend
beyond them. It is this
impression more than anything
else that lends a dynamic force
to the painting.

Antoni Tàpies
Barcelona 1923

*Ochre-Coloured Oval with Black
Incisions*, 1965
Three-dimensional matter on
wood on canvas,
194.8 x 129.6 cm
(Inventory no. 13827)
Acquired 1967

The cryptic title of the
monumental material picture
stands in a neutral relationship
to the actual effect of this relief-
like panel. Only in analysis of
the dark, coarse surface, with its
cruciform, wound-like cut, are
the various possible
interpretations revealed:
entrapment and suffering are
expressed in the motifs of the
bars, the door, and finally the
cross, but are conveyed
especially forcefully by the
material quality of the work,
whose dull impenetrability
confronts the spectator.

Cy Twombly
Lexington, Virginia 1928

Bolsena, 1969
Household paint, waxed chalk
and pencil on canvas,
200 x 240 cm
(Inventory no. L 2304)
On loan from a private
collection since 1993

The individual elements of the
work swirl around the canvas as
though caught up in a gust of
wind. The milky, white ground
expands, suggesting an idea of
its multiple layers. The scribbles,
sketches, ciphers and numbers
on the canvas assume a fluency
that corresponds to the stream –
hard to define – of memory and
association, dream and poetry,
upon which Twombly's work
feeds. The painter, whose artistic
roots lie in American Abstract
Expressionism, here translates
the proclaimed spontaneity of
the artistic language into the
graphic elements of line and
stroke, which he uses to convey
his own emotions.

Cy Twombly
Lexington, Virginia 1928

Without Title, 1971
Oil, chalk and pencil on canvas,
172.5 x 221 cm
(Inventory no. 15340)
Acquired 1993

In its complete reductionism –
the white ground is drawn over
with horizontal blue and black
lines in the upper half of the
picture – this work, executed in
1971, awakens associations with a
landscape. Where the lines begin,
beach and water seem to
separate; everything lies shrouded
in a light mist. At the same time
the abstract impression of a
rhythmic order appears, which
grows denser, following the lines
from the bottom upwards. If we
pursue this metaphor, then we
become aware that only some of
the lines keep to the horizontal.
Some are drawn straight and
precisely, while others lose
direction, veer off upwards or
downwards, or become lost in the
light background of the picture.
Here, too, we witness the
confrontation of dreamy intuition
and rational precision, which is
such a determining factor in
Twombly's work.

Emil Schumacher
Hagen 1912 – Hagen 1999

Harun, 1979
Oil on panel, 125 x 170.5 cm
(Inventory no. L 1867)
On loan from the Gesellschaft
der Freunde des Hauses der
Kunst München (the Society of
Friends of the Munich House
of Art), since 1981

The earthen, encrusted
coarseness of the surfaces of
Emil Schumacher's painting on
the one hand bears witness to
his desire as an artist to open up
new dimensions for painting
and many possibilities for the
use of materials; on the other
hand it represents a new
understanding of the painting
process, which gains plasticity in
a slow process of construction.
The application of colour by
the most varied means, even
with the artist's own hands,
serves the close and spontaneous
relationship between the
subjective sensibility of the
painter and the canvas, which
becomes a field for
experimentation. Light and
shade, failure and success, are
here close neighbours.

Per Kirkeby
Copenhagen 1938

Without Title, 1979
Oil on canvas, 208 x 130 cm
(Inventory no. 14677)
Acquired 1980

The concept of mutating
appearances and structures that
push across one another and
present the theme in ways ever
new is characteristic of the way
Per Kirkeby depicts Nature,
which is to a great extent
divorced from a metaphysical
background. With the formal
transformations of a tree, for
instance, Kirkeby depicts the
relationship between outline and
content, between the outer and
the inner, between aspect and
insight. His carefully
'constructed' pictures reflect
through their changing
structures and signs in the finely
graduated colour a sequence of
ever new ways of seeing a part
of Nature. The artist thus to a
certain extent transfers the
concept of change to the
spectator.

Eduardo Chillida
San Sebastian 1924 –
San Sebastian 2002

Buscando la Luz, 1997
Three parts, rolled steel, height
of each part approx. 798 cm,
base measurement of each
approx. 150 x 140 x 150 cm
(Inventory no. B 900)
Acquired in 2002 with funds for
'Kunst am Bau' [Art in Building]
and a private donation.

One could describe the key
theme of Chillida's plastic art as
the complementary relationship
between massive form and
empty space, an exciting
combination that also
characterises the late sculpture
Buscando la Luz. The three
curvaceous elements of the
installation, made of rolled steel
rising upwards, open out around
a common centre, which they
simultaneously enclose, thus

suggesting the idea of a space
where wind and light play.
Chillida compared this living
emptiness with musical
phenomena: 'Just as in music the
sound fills the silence with
tension, in sculpture the volume
would not be possible without
the emptiness of space.'

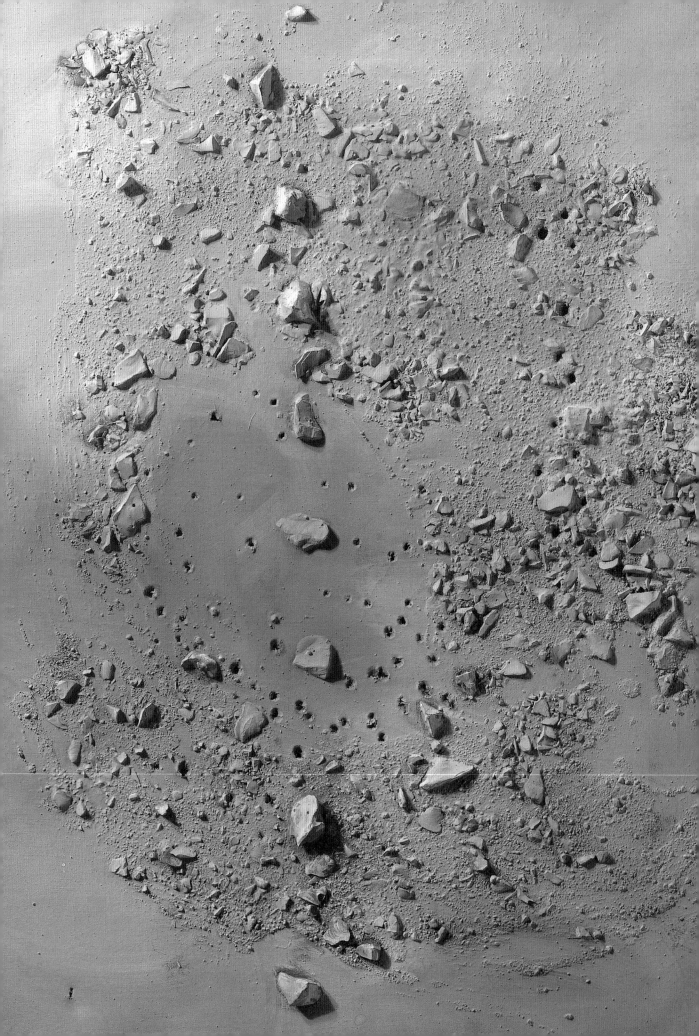

How the Image was Problematised during the Last Third of the Twentieth Century

Arte Povera, Pop Art, Fluxus, Minimal Art, Beuys, Baselitz, Capitalist Realism

In the course of the 1960s and 1970s many new attempts were made in art to criticise the aesthetics of the traditional form of the painting, and, in tandem with this, doubts were expressed about the suitability of the museum as the 'home' for works of art.

These trends are clearly and unequivocally expressed in the work of Lucio Fontana: the canvases of his 'paintings' are slit open, or perforated, or even assume a convexity, invading the space around them. In the work of another 'Arte Povera' artist, Jannis Kounellis, yet another dimension is added: in his installations what is everyday becomes 'art'. In his painting in the Pinakothek der Moderne a few black letters and symbols applied to a white canvas are presented as the enigmatic but unspectacular theme of a monumental work.

The advent in art of the everyday, the ugly and the inferior, and the much vaunted association of life and art, are reflected in the complex Fluxus movement, whose spiritual father may be regarded as John Cage, the composer, musician and artist. In the early 1960s he integrated everyday noises and theatrical action into his concerts. It was from his courses at the New York School for Research that the artists went forth who were to constitute the original nucleus of the Fluxus movement.

Not only the 'orgy-mystery' theatre of Hermann Nitsch – whose paintings are like the blood-soaked relics of mystical-sacral activities, in which pseudo-religious practices accompanied by sound effects and music create an impressive ensemble – but also the work of Joseph Beuys and his formulation of a new art concept are unimaginable without the influence of Fluxus. Joseph Beuys united the opening up of art with the everyday, as intended by the Fluxus movement, with a Romantic–utopian approach. His works go beyond the traditional generic boundaries, and evolve from real actions, replicating thought

Lucio Fontana,
Concetto spaziale
(Detail from page 86)

processes that are aimed at social change in its broadest sense.

The End of the 20th Century in the Pinakothek der Moderne was the result of one such activity, organized on the occasion of the Seventh Documenta exhibition in Kassel in 1982. Here, in *The End of the 20th Century*, the blocks of basalt – which at the time occasioned the planting of an oak tree for every block sold – also represent a symbolic reference to a process of change. The work in the Pinakothek der Moderne was made from some of the stones that were left over in Kassel, which Beuys provided with 'eyes'. The eyes not only make the blocks of basalt seem alive; in the union of the pupil-like small, conical pebbles with the large blocks of stone, using clay and felt – which in Beuy's work symbolise warmth – the concept of an organic and natural process is created. The idea of change from cold to warm, from firm to fluid, from inorganic to organic, and so on, are characteristic of Beuys's 'concept pictures', his installations and his sculptures. His approach translates the neo-Dadaist 'actions' of the Fluxus movement into an idealistic utopian art form: his works bring together the most varied of materials, shapes and objects in order to construct within a network of defined meanings the concrete form of his ideas, a form sustained by a social utopia.

'Pop Art' seems to hold up a mirror to the glittering world of the consumer. However antithetical this movement might initially seem in comparison with the earth- and nature-grounded work of Joseph Beuys, it too is based on a critical approach to art and society. The playful, 'anti-museum' stance it assumes reflects the worlds of the media and of consumerism, whose laws and mechanisms Pop Art makes its own.

Andy Warhol's self-portrait of 1967 was the result of a photograph reproduced through screen printing. About 78 versions of the portrait are known. The unique nature of each of the reproductions is due to the different colouring of the pictures, which matches the specific character of each individual portrait – though the meaning of the portrait is characterised by the very act of its duplication. Not the individual but the mass, not the content but the brand, not the person but the aura – these are the things that count in a world where outer beauty reigns supreme, in which everything can be replaced by something else and worth equals market value. Warhol's *Aids/Jeep/Bicycle*, a late work, is likewise determined by this approach: words from opposing meaning-connections are juxtaposed and superimposed on a huge canvas. With the appearance of graffiti, deliberately artistically and graphically imperfect, the picture seems to magnify newspaper advertisements to a monumental size. The superficial banality of the picture is however qualified by the black letters of the sinister word 'Aids', which run across the canvas in the foreground.

Contrary to the original intention of the artists who were its exponents, Pop Art did not only rapidly become a 'museum' style like Cubism, Surrealism or Futurism; its tendency to make its own the mechanisms of an art world dictated by the media and consumerism turned this intention into the exact opposite of what its exponents had striven for, in as much as the 'everyday' ethos of pop art found a wide access into the aesthetic of the everyday.

This inclination was resisted by 'Minimal Art', which is prominently represented in the Pinakothek der Moderne by Donald Judd and Dan Flavin, and also by Carl André, Richard Morris and Richard Serra; above all, Minimal Art resisted incorporation into the traditional system of exhibitions, dominated as this was by the concept of the picture. The works of 'Minimal Art', characterised by the desire to liberate art from diffuse content and interpretations, and to limit itself to the basics, in both shape and materials, disclose their effect through spatial relationships, and

for their stage they generally require an empty room with appropriate dimensions. This is the case for Dan Flavin's light installations, which fill the room with almost sacral light, as much as for Donald Judd, whose cubes of varying sizes require the dimensions of the room in order to be appreciated in the harmony of their proportions.

There was a school of thought in painting that opposed criticism of the concept of the traditional picture form; since the 1960s the adherents of the 'critical' school had 'escaped' from the picture format, and discovered completely new forms of expression beyond the traditional ones or the acceptance of the everyday in art. This new direction, while remaining committed to the picture-concept, questioned it in other, perhaps more cryptic, ways, and a number of works by German artists in the Pinakothek der Moderne illustrate this.

Thus, while Georg Baselitz had been turning his canvases around and his themes upside down since the beginning of the 1970s, he insisted that he was not concerned about sense and meaning, not even about the naming of the picture's subject, but only about 'good' painting. He reacted not least to the question 'figurative or abstract?', which was a theme of the discussion about painting in post-war Germany. Anselm Kiefer, Jörg Immendorff and Markus Lüpertz replied to this dilemma with figurative painting, which confronted the historically neutral post-war abstractionism with symbolic meaning and historic reference that set its sights especially on German history in relation to fascism and the partition of Germany.

Gerhard Richter and Sigmar Polke formulated in their painted works a thorough criticism of the 'image-picture' in this respect, first and foremost with regard to its authenticity, but also concerning the prejudices in which it is steeped in the world of art and museums. Polke's paintings *Nude with a Violin* and

Constructivist satirise 'art-isms' – terms that seem to guarantee the value of a painting executed in whatever style, merely through their entry into the vocabulary of art history. However, the wide diversity of styles seems also to herald the end of a development in which the spiral of innovation, once the motor of the avant-garde movement, has stopped turning. Gerhard Richter's work reflects a masterly domination of this arbitrary style. The application of different painting techniques and stylistic devices is occasionally called into question when Richter, applying a hyper-realistic technique, copies blurred photographs or brings to the canvas with meticulous precision painting apparently born of spontaneity. The background to this is criticism of painting as a deceptive device that creates illusory images, but also an engagement with the availability, relativisation and vulgarisation of the picture in its media-driven commercialisation.

Imi Knoebel and Blinky Palermo, both pupils of Joseph Beuys, problematise the picture from a different perspective, which is on the one hand characterised by Beuys's formulation of a new concept in art, but which, on the other hand, none the less remains rooted in the concept of the panel painting, in which it is reflected in many ways. Thus among the works of Palermo in the Pinakothek der Moderne we find pieces that pass from his use of a geometrical pattern as the theme for a picture, to the combination of wooden planks and canvas as the surface for the picture, to the use of a harsh palette of colours. Knoebel, on the other hand, in his *Red Knight*, combines the shabby materiality of rusty metal struts with the perfection of two rectangular chromatophores, which are mounted on this framework.

Lucio Fontana
Rosario de Santa Fé, Argentina
1899 – Comabbio, Italy 1968

Concetto spaziale, Attese
(54 P 11), 1954
Oil, glass fragments, mixed
media and ochre on canvas,
84.5 x 69 cm
(Inventory no. 14977)
The gift of Teresita Fontana,
1986

If Lucio Fontana does not deal
explicitly with the questions of
a new art concept, then, in
order to understand his *concetti
spaziali* [spatial concepts] –
which he produced from 1949
until his death – it is
nevertheless illuminating to
throw into relief the specific
understanding of space that
characterises these works. While
for centuries European painting
conveyed spatiality as an
illusion, Fontana evokes spatial
images through collages on, or
incisions and perforations in, the
canvas – that is to say, his works
intrude into space, in either a
positive or a negative way.

Lucio Fontana
Rosario de Santa Fé, Argentina
1899 – Comabbio, Italy 1968

Concetto spaziale, Attese
(59 T 132), 1959
Blue ink, cuts on canvas,
82 x 116 cm
(Inventory no. 14976)
Acquired 1986

Fontana's so-called *tagli* [cuts],
which he was creating from the
1950s onwards, invite
meditation: the precision of the
cuts with which the artist opens
up the variously prepared
canvases backwards or forwards
are virtually calligraphic strokes.
They enable the spectator to
experience a spatiality that exists
only in his own imagination: he
will recall a space behind the
canvas or will see the space of
the painting opening up as his
own.

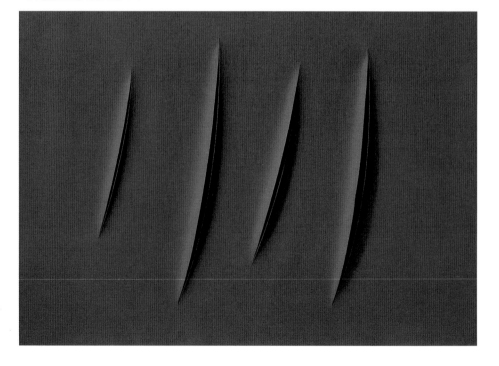

Alberto Burri
Città di Castello 1915 –
Nice 1995

Grande sacco, 1958
Sackcloth, 200 x 188 cm
(Inventory no. 14651)
Acquired 1980

Burri's work, like that of Lucio
Fontana, evolved from a new
understanding of painting – in
so far as the work of the Italian
artist can be classed under the
definition 'painting', vacillating
as it does between assuming the
form of an object and that of
the traditional wall-hung
painting. Typical of Burri is not
only the specific materiality
through which intentional wear
and tear and the work process
are evoked, but also the picture
surfaces marked by 'wounds'. In
the case of *Grande sacco* the
artist's conscious joining

together again of the material
contrasts with the image of the
old, threadbare sackcloth, riddled
with holes. The two horizontal
seams run across the canvas as an
expression of the artist's will to
design, which pursues the idea of
giving precedence to harmony
and order.

Jannis Kounellis
Piraeus, near Athens 1936

Without Title ('Z–+V'), 1960
Oil on primed cotton cloth,
136 x 287 cm
(Inventory no. 14557, GV 23)
Acquired in 1978 with the help
of PIN, the Friends of the
Pinakothek der Moderne

Jannis Kounellis's works were
created against the background
of the Arte Povera movement in
Italy. The protagonists of this
movement not only worked with

an art concept expanded to
include installations, objects,
collages, and so on, but found in
their concentration on 'poor',
worthless materials, a possibility
for expression of their criticism
of an over-technicalised society
and 'high art', whose content
lost any significance behind a
brilliant exterior. The black
characters that Kounellis has
placed on white paint over a
simple, light ground of cotton
cloth, are to be interpreted as an
aspect of this 'criticism of
civilisation'. The letters and signs

have no connection with one
another, and because of this are a
reminder of the primitive magic
of writing and communication,
which in the age of technical
communication have become
debased to mere signals and brief
phrases.

Blinky Palermo
Leipzig 1943 –
Kurumba, Maldives 1977

Straight, 1965
Oil and pencil on canvas,
80 x 95 cm
(Inventory no. WAF PF 45)
Gift of the Wittelsbacher
Ausgleichsfonds [the Wittelsbach
settlement fund]. The collection
of Prince Franz of Bavaria

This early work of Blinky
Palermo is linked to the late
works of Piet Mondrian. In each
case stripes in primary colours –
blue, red and yellow – cross the
canvas horizontally and vertically.
But whilst Mondrian's aim was
to reproduce in the rhythm and
order of his composition a
harmonic system, Palermo calls
into question this traditional idea
so fundamental to European art.
His composition seems to be
arbitrarily cut off by the borders
of the canvas, which gives the

impression that it could extend
itself further to infinity. At the
same time the structure does
not let the spectator rest, and,
when one looks further, opens
up ever new planes of visual
perception, thus forcing the
spectator to consider a new way
of understanding the picture as
an art form.

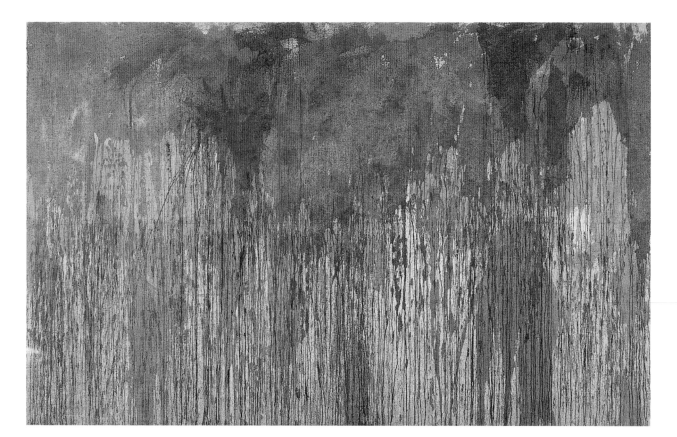

Hermann Nitsch
Vienna 1938

Station of the Cross (Schüttbild
– picture created by pouring
paint from various heights and
angles rather than using a
brush), 1961
Mixed media on canvas,
200 x 300 cm
(Inventory no. GV 84)
On loan since 1986 courtesy of
PIN, the Friends of the
Pinakothek der Moderne

The title of Hermann Nitsch's
'Schüttbild', *Station of the Cross*,

is in itself an indication of the
sacral origin of the work. The
painting, which seems to
correspond to American 'action
painting' or to European
Informal Art, was created as a
reminder of 'orgy-mystery plays'.
These theatrical performances
consisted in an emotional
liberation via deep psychological
means involving precivilisational
sacrificial and fertility rites, and
the 'Schüttbilder' were created as
a preparation for these rituals or
during the course of them.

Blinky Palermo
Leipzig 1943 –
Kurumba, Maldives 1977

Dead Pig, 1965
Synthetic resin paints and
charcoal on cotton cloth and
wood, 155/115 x 116 x 6 cm
(Inventory no. WAF PF 58)
On loan from the Wittelsbacher
Ausgleichsfonds [the Wittelsbach
settlement fund] since 1985
The collection of Prince Franz
of Bavaria

Dead Pig is in many respects a
reflection of the artistic
atmosphere of the Düsseldorf
Academy, where Palermo's
teacher, Joseph Beuys, was a
significant figure for him. The
work, which was developed

from a chance find – a broken
wooden plank – is a reminder
equally of Beuys's nature-
oriented use of materials and
themes, and of Palermo's own
central questioning of the
boundaries and possibilities of
traditional art. The outlines of a
pig suspended from a beam
develop from an abstract form
on the wooden plank, which is
mounted on the canvas as a
horizontal, upper border. Thus
not only is the expectation of
illusion in the image on the
canvas disappointed, but also its
transformation into an object – a
thing pregnant with symbolism
– is begun.

Blinky Palermo
Leipzig 1943 –
Kurumba, Maldives 1977

Triptych, 1972
Three-piece dyed cotton
material, stitched up
horizontally, backed with cotton
cloth, mounted on stretchers,
each 210 x 210 cm, depth of
the bands of colour 59 cm,

78 cm and 73 cm
(Inventory nos 14351–14353)
Acquired 1974

This three-part work of 1972,
which assumes in title and
structure the altar-form of a
triptych, is the final example of
works using materials in
Palermo's oeuvre and heralds at
the same time his related series
of metal pictures. The rigid

arrangement of the three panels
does not assume the
symmetrical axis that is the basis
of a triptych, but is based on
three broad horizontal bands,
into which each canvas is
divided. The development of the
colour from bands of black
below to lighter tones in the
upper part holds its own against
this horizontal arrangement, so
that visually the impression of a

flow running against resistance
is created – the repeated
development of light from dark.

George Segal
New York 1924 –
South Brunswick 2000

*Alice, Listening to her Poems and
Music,* 1970
Plaster, wood, glass, cassette
recorder, 240 x 240 x 82.5 cm
(Inventory no. B 657)
Acquired 1973

The reality reference to the
'environment' in which George
Segal remembers the poet Alice
Notley is called into question
over and over again. The life-
size form of the seated woman
in plaster conveys a very life-like
although colourless image of
Alice, whose white, vulnerable
body sits opposite a compact
black wall. Completely true to
life, integrated here like an *objet
trouvé*, as an element of reality,

we see the portable radio
playing Alice Notley's poems,
which thus adds another facet of
reality to the work. In contrast,
the totality of the elements of
the sculpture conveys the
impression of a strong alienation
from real life. This 'New
Realism' provides, in advance of
Pop Art, a direct reference to
reality with the realisation of an
alternative world governed by
the laws of art.

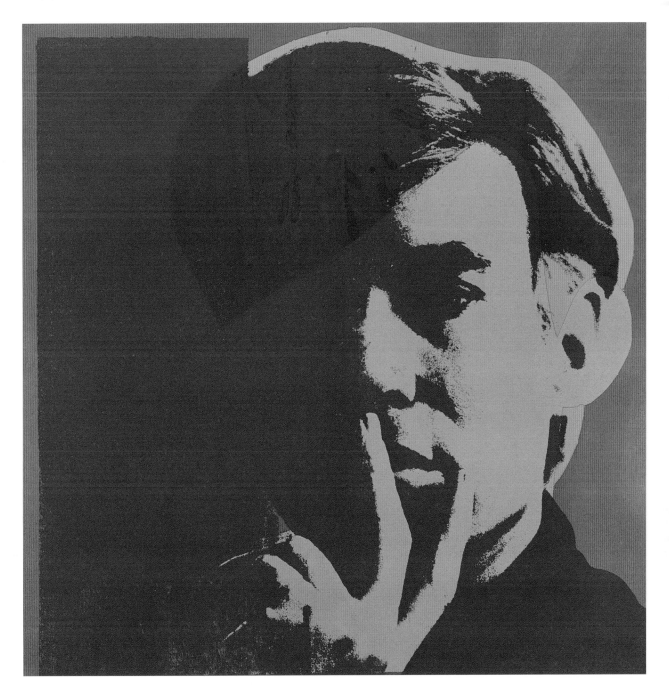

Andy Warhol
Pittsburgh 1928 –
New York 1987

Self-Portrait, 1967
Acrylic on canvas, 183 x 183 cm
(Inventory no. 14254)
Acquired 1972

Perhaps nothing defines the oeuvre of Andy Warhol more than his serial manner of working. The infinite multiplication of the individual, the individual melting into the crowd, reflects a principle of the consumer society that Warhol made the basis of his art and in which he makes no exception with his own portrait. Warhol's self-portrait of 1967 exists in at least 78 versions, which differ in colour and size. The mood of the sitter, his presence, may be otherwise conceived in a different coloured form of the portrait, but comes from outside, like a second skin or surface over the features of the artist, who poses mysteriously – consciously or unconsciously – with the prescribed vocabulary that artists have used for centuries to portray a melancholic.

Andy Warhol

Pittsburgh 1928 –
New York 1987

Aids / Jeep / Bicycle, 1985 or 1986
Synthetic resin paint on canvas,
294.5 x 457 cm
(Inventory no. 15555)
Acquired 2001

The exploitation of 'strange' pictures in the production of his own works was a characteristic of Andy Warhol's work from the outset, and this manipulated reproduction becomes especially accentuated through the style and themes of his late work. Warhol depicts on increasingly large canvases the trivial icons of the consumer society. The pretension to absoluteness, which these pictures lay claim to in their publicity, triggers a confusing echo in Warhol's compositions. He encounters here 'antagonists', who are accustomed to questioning the affirmative, self-evident truth of urban idols. Thus in the painting *Aids / Jeep / Bicycle* the monumental word 'Aids' intrudes like bad news in front of the symbols of contemporary mobility. The images of the bike and the car, clearly copied from a newspaper advertisement, appear almost fragile behind the threatening black writing. Yet everything in this picture has a fragmentary, ephemeral character, and is merely sketched in: here are the signs and words of a superficial lifestyle, in which even the threat to our very existence is now barely perceived.

Carl André

Quincy, Massachusetts 1935

*Hot Rolled Common Steel
(Steel Row)*, 1968
Ten steel plates, each
100 x 100 x 1 cm
(Inventory nos B 711 a–k,
GV 21)
Acquired in 1977 with the help
of PIN, the Friends of the
Pinakothek der Moderne.

The work *Hot Rolled Common Steel* belongs to the 'element series', to work complexes that Carl André developed after 1960. The ten absolutely identical plates of steel are assembled to create a path that can be followed in various directions, and can be crossed diagonally or in a straight line. Carl André, one of the most important exponents of 'Minimal Art', created a basic geometric shape in an everyday material whose impact is contributed to just as much by the perspective of the spectator as the work itself is conditioned by its surroundings.

Richard Serra
San Francisco 1939

Plate Roll Prop, 1969–78
Lead with antimony, plate:
125.5 x 124.5 x 1.5 cm;
roll: diam. 6 cm approx.;
length 150 cm
(Inventory no. GV 59)
On loan since 1980 courtesy of
PIN, the Friends of the
Pinakothek der Moderne

Richard Serra's sculptures are
characterised by the concept of
balance, by their immanent
equilibrium, which can be
directly experienced by the
spectator through the feelings of
his own body in relation to
these monumental works –
created from 1970 onwards –
which he can actually enter and
in which he can move around.
In the case of the work *Plate
Roll Prop* we are talking about a

much smaller sculpture, but it
nevertheless spontaneously
conveys as the central idea the
unstable equilibrium between
the wall, the roll of iron and the
plate of steel leaning against it. It
is this concrete and immediate
experience of physical legitimacy
alone that is the fundamental
concern of Serra's art.

Dan Flavin
New York 1933 –
Riverhead 1996

'Monument' for V. Tatlin, 1969
Seven luminescent tubes, lime-
white fluorescence,
305 x 71 x 11 cm
(Inventory no. GST 6)
On loan since 1999 from the
Museumsstiftung [Museum
Foundation]

This group of works by Dan
Flavin was created between 1964
and 1969, but it was not until 30
years later that the individual
components could be brought
together again in the Pinakothek
der Moderne in Munich. It
examines one of the most
significant works of
Constructivism, the *Monument to
the III International*, which was
conceived by Vladimir Tatlin in
1920. Dan Flavin's work,
composed of simple luminescent
tubes, reflects both the idea of
material taken from the basic,
everyday world (which Tatlin
also wanted to use for his
memorial) and the concept of a
social utopia – which again was
also a motive behind Tatlin's
work. It can be seen again in
Flavin's work in the almost
sacral light–space created by the
simple luminescent tubes.
Beyond this, the arrangement of
the tubes provokes different
associations, a feature also often
linked to Tatlin: one of the four
pyramid-like compositions in
which Flavin places the tubes is
reminiscent of the Empire State
Building, but otherwise the
installations assume the tower-
shapes envisaged by Tatlin, so
that allusions to the symbolic
constructions of capitalism
and consumerism confront
one another.

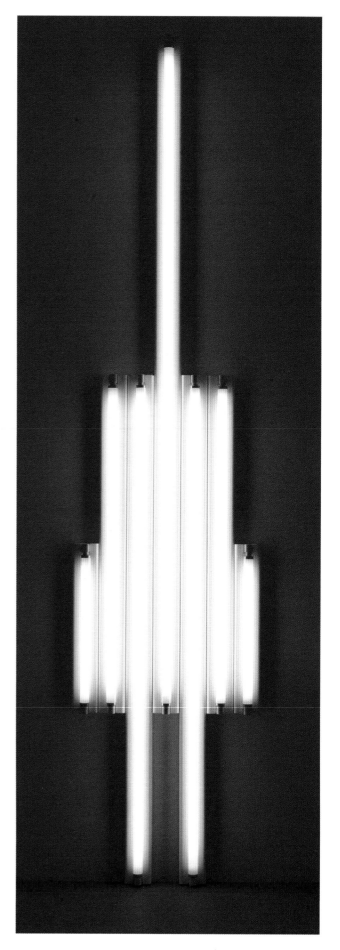

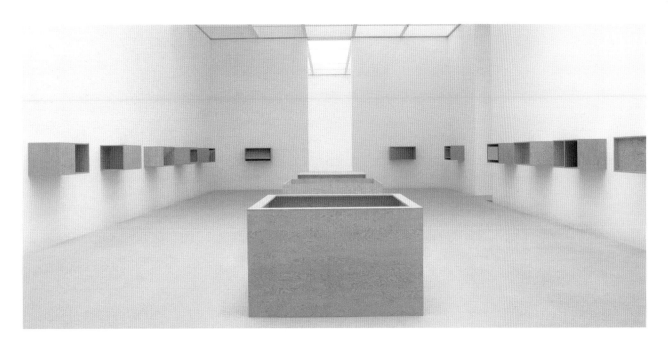

Donald Judd
Excelsior Springs, Missouri
1928 – New York 1994

Untitled, 1978
16 wall–boxes, American
Douglas Fir plywood
Each unit 19.75 x 39.5 x 19.75
in/49.38 x 98.75 x 49.38 cm
(Inventory nos L 2441
(1/16–16/16))
On loan from a private owner
since 2002

Untitled, 1978
American Douglas Fir plywood,
each unit 36 x 60 x 60 in/90 x
150 x 150 cm
(Inventory nos L 2440
(1/3–3/3)

On loan from a private owner
since 2002

From the beginning of the 1960s
Donald Judd worked on the
concept of works of art that not
only depart from that illusory
reflex of reality, but which also
oppose the complex and
destructive worlds of the media
and the consumer with the
formal 'basic values'. His works,
which make use of
unpretentious, everyday materials
and limit themselves to simple
geometric shapes, made Judd one
of the most important exponents
of 'Minimal Art', a movement for
which he also formulated the
fundamental theory.

Judd's wall-mounted
composition consisting of 16
boxes varies the relationships of
measurement and size, which
repeat themselves in each
element of the multipartite
work. The complex play of
shadow and light, volume and
empty space, interior and
exterior, is based on the
fundamental givens; the
resulting effect of the work is
almost meditative.
 The three large rectangular
boxes of the second work, also
composed in 1978, stand on the
floor; they too have the same
measurements and are
constructed of the same
material, so that the decisive

element lies in the similarity of
the dissimilar, that is to say in a
difference that comes from the
person of the spectator, who in
each case will encounter the
work from very different
perspectives, under different
light relationships and in
different moods.

Robert Morris
Kansas City 1931

Without Title, 1974
A width of felt, 533 x 186 cm
(Inventory no. GV 61)
On loan since 1980, courtesy of
PIN, the Friends of the
Pinakothek der Moderne

In contrast to Judd, Flavin and
Serra, Morris, more or less their
contemporary in age, worked
after 1967 not with hard
materials but with soft fabrics,
which are unsuitable for any
form of construction. His felt
sculptures are a contrast to clear
outline and defined form

because of their soft drapes, and
their arrangements convey the
impression of chance and
changeability. In fact the
development of plastic art
suggests the idea of motion,
whilst Morris spreads the felt
out on the floor and 'cuts out',
so that he can then secure the
fabric width in a layer or folded
onto the wall. The pieces of felt
that are laid out on the floor
assume a more or less 'natural'
shape, following the effects of
their weight.

John Chamberlain
Rochester, Indiana 1927

Horsepucky, 1976
Painted and chromium-plated
sheet steel, 188 x 109 x 63.5 cm
(Inventory no. L 2426)
On loan from Dr Hans Moll,
Munich, since 2002

John Chamberlain's art has its
origins in a new reference to
reality, which also inspired his
contemporaries, the 'Nouveaux
Réalistes' Arman, Jean Tinguely
and César, to make elements of
reality in the greatest variety of
forms as the point of departure
for their works. Initially

Chamberlain worked with
sheets of bodywork that he
found at the scrap-dealers, but
later he had the material for his
sculptures delivered directly
from the car factory, so that he
himself could mould it into the
shape he required. The sculpture
Horsepucky, which is presented as
a wall-mounted relief, is
enlivened by the contrast of the
colours red and green as well as
its shape – reminiscent of the
saddle and harness of a horse;
the shape in conjunction with
the title allows the spectator's
mind enormous freedom of
association.

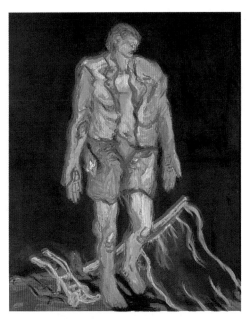

Georg Baselitz
Deutschbaselitz, Saxony 1938

A New Fellow, 1966
Oil on canvas, 162 x 130 cm
(Inventory no. L 2408)
On loan from a private owner
since 2002

Two Foresters from Meissen, 1967
Oil on canvas, 251.2 x 200.7 cm
(Inventory no. 15331)
Acquired 1992

The move from East to West
Germany and the accompanying
confrontation with abstrac-
tionism – the almost exclusive
style of painting in the West –
was for Baselitz, who had
completed a classical education at
the East Berlin Academy, an
experience that may be
considered the key to his own
artistic development. His group
of 'pictures of heroes' begun in
1965, was a completely objective
and, in addition, symbolic series
of paintings; it confronts the
contemporary hegemony of
abstractionism not only with a
form of painting that returns to
figurative art, but also breaks the
taboo of 'lack of history', which
in post-Fascist Germany was

closely linked with Abstract
Expressionism. Baselitz's *New
Fellow*, wounded and stigmatised,
leaves a blood-red battlefield on
which the symbols of Germany's
closeness to the Earth – a
plough and a cart – have been
lost.

As with this painting, *Two
Foresters from Meissen*, which was
painted two years later, is not
limited by Baselitz to the
attempt at a 'new' figurative art
form. Both pictures take as their
theme something more – the
question of immanence in art: if
in *A New Fellow* abstract
structures are set free by a
function of what is represented,
then in *Two Foresters from
Meissen* the basic question posed
concerns the function of illusion
in art, about its meaning and its
veracity. Both the green
uniformed figures, seen from
behind, fragment and leave the
view clear on the rough canvas
whilst dogs and tree trunks rend
the air like an explosion –
a picture of horror and
disintegration, which refers the
spectator less to reality than to
his own perception of a
conventional art form.

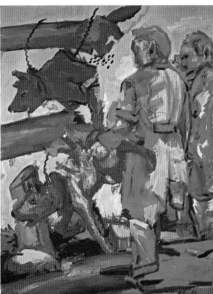

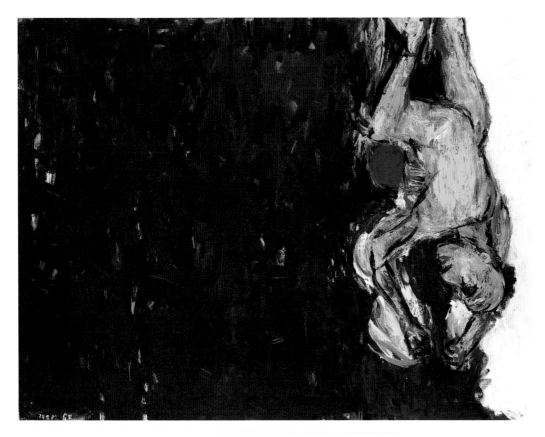

Georg Baselitz
Deutschbaselitz, Saxony 1938

The Drummer, 1982
Oil on canvas, 250 x 330 cm
(Inventory no. L 2320)
On loan since 1993 courtesy of
PIN, the Friends of the
Pinakothek der Moderne

The monumental work *The Drummer*, painted a decade after Baselitz started turning his pictures upside down, emphasises in a new way the artist's declared indifference towards abstractionism and figurative art. A black wall fills the whole picture and forces the drummer to the right-hand edge of the painting. Its effect is one of threatening power, against which the drummer must defend himself, so that the possibility of action is conveyed to the observer. The colours of the picture – black, red, yellow – are also pregnant with meaning. The (German) spectator will associate them with the German flag, just as the title of the painting might remind him of Günther Grass's *Blechtrommel*, a book that has a part in and reflects on German history. But is this the theme of the painting, which is dominated by the black, flickering surface interspersed with 'glimpses of light'?

Markus Lüpertz
Liberec, Bohemia 1941

Without Title (Atelier), circa 1974
Distemper on paper on canvas,
193 x 255 cm
(Inventory no. WAF PF 29)
On loan since 1985 from the
Wittelsbacher Ausgleichsfonds
[the Wittelsbach settlement
fund]
The collection of Prince Franz
of Bavaria

Markus Lüpertz, whose painting, like that of Georg Baselitz, evolved from the desire to confront international abstractionism with a new form of figurative art, connects to a typically German thought tradition with the heroic gestures of his subjects and his assessment of the artist as the 'monk in the cathedral of Art'. But Lüpertz breaks this line of tradition with the irony of his assertions and the contradictory nature of his paintings. This picture without a title, described in parentheses as *Atelier*, shows canvases stacked one against the other in an attic. A half-length portrait of a soldier crowned with an empty cap and helmet in the classical style finds an echo in the smaller image of a palette resting on a pedestal. Is this painting an allegory for some kind of memory stored in an attic?

Anselm Kiefer
Donaueschingen 1945

Nero Paints, 1974
Oil on canvas, 220 x 300 cm
(Inventory no. WAF PF 51)
On loan since 1985 from the
Wittelsbacher Ausgleichsfonds
[the Wittelsbach settlement
fund]
The collection of Prince Franz
of Bavaria

The effect of Anselm Kiefer's
monumental canvases is all the
more severe and monumental
because, in addition to their
colourful design, the artist loads
them with straw, sand or ash,
which lends the pictures the
appearance of a structure in
relief. In this way Kiefer attains
a particular form of pathos, a
formal analogy for the deeply
symbolic title, which links
German Fascism with German
myth, and the contents of his
work. *Nero Paints* depicts a giant
palette hovering over a desolate
landscape, and presents this as
the work of a solitary
'Superman', in which images of
both dictators – Nero and
Hitler – move across one
another.

A.R. Penck
Dresden 1939

N. Complex, 1976
Ripolin on canvas, 280 x 280 cm
(Inventory no. 14633)
Acquired 1980

If one starts from Penck's conviction that the picture is 'the decisive criterion, not for explanations, accessibility, interpretation, but for experience', then one can leave the wealth of symbols and signs in the painting *N. Complex* to a self-indulgence of associations. Like an African picture carpet, the work spreads out before us many figures to each of which is assigned its own powerful colour. For the most part the symbols seem to have been taken from the wild: the orange tiger, the black snake, the red dancer and the turquoise-coloured octopus represent a world governed by instinct and nature, and stand in contrast to reflective human sensibility in the shape of the spectator at the left-hand edge of the picture, or in the figure screaming in the midst of the picture with a Medusa-like head. In the central position Penck places a rectangular grey mask above a tower of grey, unrealistic shapes, which may be seen as a reference to the technical dimension of our existence.

Jörg Immendorff
Bleckede, near Lüneburg 1945

Lidl Polar Bear, 1968
Painting in two parts, dispersion on cotton cloth, 130 x 150 cm; 130 x 125 cm
(Inventory no. WAF PF 35)
On loan since 1983 from the Wittelsbacher Ausgleichsfonds [Wittelsbach settlement fund]
The collection of Prince Franz of Bavaria

Immendorff's work is dominated by the question of the social relevance of art in general and of his own painting in particular. As a result, the artist, who was a pupil of Beuys at the Düsseldorf Academy, withdraws to an ironic-neo-Dadaist position, as the 'Lidl' movement – created principally by him in 1968 – shows. The Lidl bear looks out at us good-naturedly from the large two-part painting *Lidl Polar Bear*, rather like a clumsy cuddly toy. He represents an ineffectual innocence, which assigns to the artist the role of a 'magician' who performs his tricks outside the realm of reality.

Sigmar Polke
Oels, Lower Silesia 1941

Nude with a Violin, 1968
Dispersion on canvas,
90 x 75 cm
(Inventory no. WAF PF 34)
On loan since 1985 from the
Wittelsbacher Ausgleichsfonds
[the Wittelsbach settlement
fund]
The collection of Prince Franz
of Bavaria

Constructivist
Dispersion on cotton cloth,
150 x 125 cm
(Inventory no. WAF PF 39)
On loan since 1985 from the
Wittelsbacher Ausgleichsfonds
[the Wittelsbach settlement
fund]
The collection of Prince Franz
of Bavaria

Both *Nude with a Violin* and
Constructivist are satires, not only
on the theme of 'Modern Art'
but also on its ready reception
by an eager, educated
bourgeoisie: long after the
avant-garde movement had had
its day, the bourgeoisie engaged
with every new trend in the art
world, and took it to absurd
lengths. But Polke evades this
situation: he calls into question
both positions – that of the
artist and that of the spectator –
by caricaturing them. He draws
freely on the rich store of
images in modern art,
questioning the thematic and
stylistic use of everyday
materials and especially
indifferent painting. Decisive in
this procedure is the
relativisation of the picture
created by an artist in
comparison to the images
produced by every other
medium, which Polke exploits
unscrupulously. By vulgarising
Cubism, Constructivism and
Abstractionism in his works,
painting on blankets or
tablecloths, printing over or
staining his surfaces, he
formulates a new aesthetic,
which soon frees itself from the
lofty realm of 'high' art, and
rapidly assumes the role of a
new autonomy.

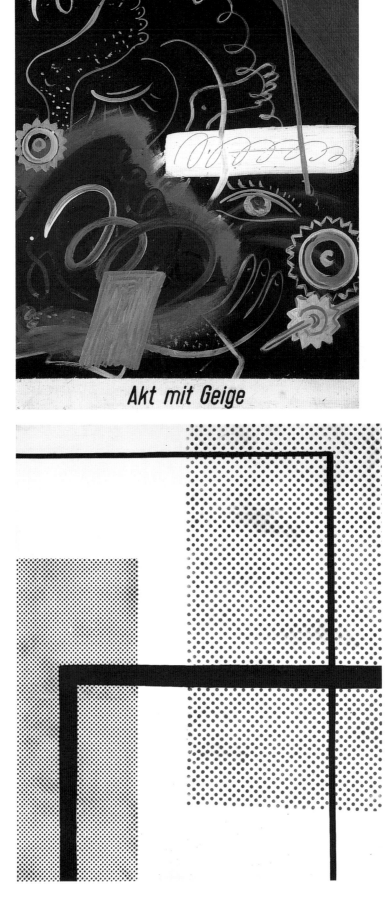

Akt mit Geige

Sigmar Polke
Oels, Lower Silesia 1941

Eight *Loop Pictures (Ratio, Providentia, Alacritas, Velocitas and Firmitudo, Acrimonia, Virilitas, Experentia and Solertia, Audatia),* 1986
Graphite, silver, sepia on canvas, each 200 x 190 cm or 190 x 200 cm
(Inventory nos 15260–65)
Acquired 1992
(Inventory nos GV 102–103)
On loan since 1992 courtesy of PIN, the Friends of the Pinakothek der Moderne

The eight *Loop Pictures* are a part of a cycle of pictures that Sigmar Polke created for the 43rd Venice Biennale. They are works in which he invokes the spirit of Albrecht Dürer (1471–1528), whose visits to Venice represent the confrontation of contemporary German painting with the Italian Renaissance. Polke takes the main theme of his pictures, the decorative spiral scrolls, from a print of Dürer's of 1522 showing the triumphal procession of the Emperor Maximilian I. In these pictures the 'loops' represent the Virtues that accompany the ruler. Polke contrasts these purely artistic and at the same time extremely artificial creations with the realistic–naturalistic basis of his pictures. The painter has constructed this image with a great variety of materials – graphite dust over lacquer, silver or insect wings – and thus the picture represents a visual 'experiential field' constituted from natural phenomena.

Gerhard Richter
Dresden 1932

Stukas, 1964
Oil on canvas, 80 x 80 cm
(Inventory no. WAF PF 22)
On loan since 1985 from the Wittelsbacher Ausgleichsfonds [the Wittelsbach settlement fund]
The collection of Prince Franz of Bavaria

If on the one hand Gerhard Richter's art is characterised by the free, masterly command of a variety of styles, that is to say by taking purely artistic questions as his themes, then on the other hand his work evolves from a media-critical approach. Richter proceeds from ordinary photographic material, which he then reproduces in paint in pictures like *Stukas.* Themes from the world of the German middle class stand alongside pictures that hark back to Germany's past, in which the unfocused quality of the often fragmentary photographs may be seen as representing the dubious informational content of the

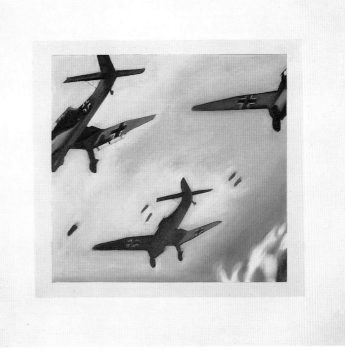

pictures. As in American 'Pop Art', Richter's image drawn, without comment from him, from other media, appears to be critically broken through its translation into paint.

Gerhard Richter
Dresden 1932

Curtain, 1966
Oil on canvas, 200 x 195 cm
(Inventory no. 14262)
Acquired 1972

Richter's *Curtain* may be interpreted as an allegory of his artistic conception, something that may be concluded in the light of the following comment by the artist: 'Doors, curtains, relief pictures, discs, etc., are perhaps allegories for the dilemma that while our vision certainly allows us to recognise things, at the same time recognition limits reality and makes it impossible.' These words give voice to the artist's complete scepticism with regard to an investigation or interpretation of reality through his artistic creation; his comment could also serve as a slogan for his *Curtain*. The illusory lack of focus in this painting allows the picture to fluctuate between abstract beauty and the inadequacy of the illusionary–representational picture, which does not in fact help the spectator towards a new knowledge of its content, but instead throws him back on his own visionary process.

Gerhard Richter
Dresden 1932

Prague, 1883, Abstract picture no. 525, 1983
Oil on canvas, 250 x 250 cm
(Inventory no. L 2030)
On loan since 1985 from the collection of Duke Franz of Bavaria

During the 1980s Gerhard Richter returned to an abstract, 'informal' style of painting, which appears to be directly connected to his education under Karl Otto Götz at the Düsseldorf Academy in the 1960s. Whilst his teacher's pictures were the result of free, gestured artistic expression, Richter's 'informal' painting is the result of a controlled, perfected process, of an art form that allows self-reflection from the perspective of history.

Stephan Balkenhol
Fritzlar, Hessen 1957

Large Head, 1992
Wawa wood, with colour definition, 226 x 68.5 x 81.5 cm
(Inventory no. B 868)
Acquired 1993

The inner tension of Stephan Balkenhol's sculptures, which present themselves as emphatically naturalistic and neutral, rests on the monumentalisation of the everyday. This is especially so in the case of his 'portraits', which frequently not only exceed the actual size of the model but also partially transform them on a reduced scale. The spectator is faced with a related and yet quite different appearance, for Balkenhol's images of people are based on the representation of the average. These faces appear emotionless, lightly cut as they are into the soft wood and applied with a few coloured highlights. Free of identifying personal traits, they offer themselves as a pattern of identification for anyone and everyone.

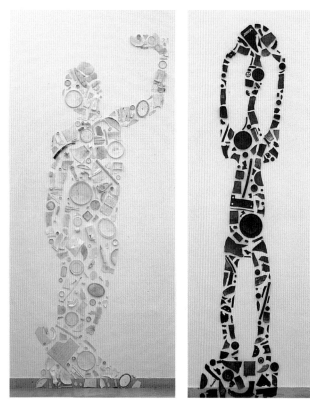

Tony Cragg
Liverpool 1949

European and African Myth, 1985
Respectively, white and black
plastic waste, height
approximately 600 and 550 cm
(Inventory nos B 810
and B 838)
Acquired 1985

Cragg's outsize wall-mounted
reliefs are assembled from relics
of throw-away society and result
in shadowy silhouettes whose
outlines recall both Sansovino's
famous late Renaissance figure
of Bacchus in Florence and,
equally, African ritual sculpture.
Cragg's ideas move on two
planes. He wants to caricaturise
an affluent society, whose
undifferentiated consumerism
extends even to the arts. With
European and African Myth,
Cragg catches the indifference
and the unlimited availability of
pictures as the source of
present-day art, not only
completely directly, in the
material nature of his sculpture,
but also technically.

Joseph Beuys
Krefeld 1921 – Düsseldorf 1986

Earth Telephone, 1968
Telephone, lumps of clay with
grass, cables, mounted on a
wooden board, 20 x 47 x 76 cm
(Inventory no. 2376)
On loan since 2002 from the
Klüser Collection, Munich

The fundamental difference of
the worlds from which the
telephone and the lump of clay
stuck with grass come is
revealed spontaneously to each
individual spectator. The feelings
that they provoke are equally
different. Whilst the lump of
earth can be touched,
experienced sensually, the
telephone promises only
indirect, mediated contact. It
could stand for the anonymity
and isolation of the individual in
a high-tech world, in contrast to
which Beuys summons up again
and again images of a primitive
world pregnant with symbolism.

Joseph Beuys
Krefeld 1921 – Düsseldorf 1986

The End of the 20th Century,
1983
Basalt, clay, felt, 44 stones, each
approx. 48 x 150 x 40 cm
(Inventory no. GV 81)
On loan since 1983 courtesy of
PIN, the Friends of the
Pinakothek der Moderne

The End of the 20th Century was
born of a campaign initiated by
Joseph Beuys in 1982 on the
occasion of the Seventh
Dokumenta Exhibition in
Kassel. He had blocks of basalt
piled up that were then available
for people to purchase. An oak
tree was planted from the
proceeds of the sale of each
stone. This process of
transformation, typical of
Beuys's work – changing what
is dead, cold and inorganic into
something alive, warm and
organic – was continued by him
with the basalt blocks that were
left over, though in a different
way. He had a small conical
piece of stone cut out of each
block and then set it back into
the stone with earth and felt,
materials representing warmth.
The basalt blocks were thus
brought to life with eyes,
because the cones appeared to
move and had the effect of eyes,
so that the whole group of huge
stones looked not so much like
a field of ruins as a herd of
large, prehistoric animals. The
work as it is shown here in
Munich also has a special
resonance in that Joseph Beuys
assembled the work together
himself at the beginning of the
1980s in the Haus der Kunst,
and then placed it in position at
the end of the review of the
modern arts.

Joseph Beuys
Krefeld 1921 – Düsseldorf 1986

Capri-Battery, 1985
Lemon, filament lamp with plug
in socket, 8 x 11 x 6 cm,
multiple in 200 + 50 ex.
(Inventory no. L 2384)
On loan since 2002 from the
Klüser Collection, Munich

In this work, conceived only a
few months before his death,
Beuys brings his idea of Nature
as an eternally self-renewing
source of energy once again to a
climax, repeating a theme he had
frequently used before. It is an
intensely illuminating image in
all senses, down to the colour of
the yellow light bulb, which is
charged by the lemon as a
source of energy: while the
lemon is part of the unbroken,
energy-releasing chain of
metamorphosis in Nature, the
light bulb must obtain its power
to give light from a foreign
source. It belongs to a different
cycle, which functions according
to its own principles, but
ultimately also acquires its
energy from Nature.

Imi Knoebel
Dessau 1940

Red Knight, 1981
Acrylic on wood, iron
framework, approx.
250 x 200 cm
(Inventory no. 15439)
Acquired 1995

The effect of the *Red Knight*
unfolds in a field of tension full
of opposing elements: the panels
are mounted on old metal
supports leaning against the wall
and occupy a position
somewhere between sculpture
and painting. They are covered
with a coat of red paint, which
in its pristine state seems to be
stimulated by the purist–
perfectionist aesthetics of the
Minimalist Art movement, while
the link between the title and
the shape of the *Red Knight*
allows completely objective
associations. Knoebel's art
reflects not least his period of
study under Joseph Beuys and a
new art concept manifest in the
latter's work, a concept that
seeks to remove the boundaries
between everyday waste, a
chance find and an art object in
order to open art up to new
forms of expression and other
possibilities of creating the
desired effect.

Arnulf Rainer
Baden, near Vienna 1929

Cross Picture, 1990
Oil on paper and wood in
aluminium frame,
201.5 x 124.5 cm
(Inventory no. 15248)
Acquired 1991

The shape of the cross, which
along with other formats was
the base for Arnulf Rainer's
'over-painting', lends his work a
special value and depth. If the
perception of his rectangular
'over-paintings' develops in the
thought pattern of ideas of
concealment and disclosure, the
imaginary discovery of a layer of
the picture of which only a
small corner remains visible,
then the shape of the cross lends
a dramatic dimension to the
visual interplay. This is
particularly the case for our
example of 1990, a broad, tiered
cross, which except for one
section at the lower right-hand
corner of the cross disappears
beneath a layer of black colour.

New Media, Photographs and Video

New media, photographs and videos are not represented in great breadth in the Pinakothek der Moderne, but what is here consists of significant individual artworks. Important works have been acquired since the 1990s, and essential support for acquisitions in the field of photography was granted by the Siemens Arts Programme. This sponsorship initiative, which was started up at the end of the 1980s, envisaged the formation of a collection of contemporary international photographs, with the idea of incorporating it into the existing collection of the Pinakothek der Moderne. Thus, on the one hand, photographs should be judged as a prominent artistic medium in their own right; on the other hand, the arts programme sought to promote a dialogue between the photograph and other genres – in particular painting and video.

The Siemens Arts Programme purchased important bodies of work of contemporary photography, concentrating on works that in the modern era continue the traditional line of factual–documentary photography orientated towards conceptual art. Meanwhile the museum focused its interest on significant individual photographic works in the field of staged photography.

Jeff Wall's *Eviction Struggle* (1988) is the first of these acquisitions. The large transparency presented in front of a light box allows reflection on the relationship between photography and painting. The central group of figures, which represents an everyday scene and is apparently seen and photographed by chance by the photographer, proves on closer inspection to be carefully staged in the manner of a historical painting, and thus definite concrete comparisons can be drawn with, for example, the paintings of Nicolas Poussin. Apart from the precise photographic light and colour employed, there is a theatrical element present, which finds expression in the stance and gestures of the people involved as well as in the arrangement of the central group of figures and the spectators standing around.

Just as Jeff Wall's large-format photographs always ultimately appear to be rooted in a 'story', a narrative element can be detected in the suggestive pictures of Sam Taylor-Wood. However, it is not a case here of 'action' in the traditional sense. The sequence of small photographs that are arranged on the lower edge of the huge main picture seem to reflect a train of thought, a series of inner pictures evolved during a dream or a daydream. The photographer's own, unrealistic logic in

Sam Taylor-Wood,
Soliloquy III
(Detail from page 126)

this area is reflected not least in her distorted and expanded perspectives. She forces the spectator's gaze to slow down to a speed of perception that corresponds to the order of events represented. The English artist, perhaps in a more concrete way than Jeff Wall, relates to the paintings of past eras in the production of the large principal panels of these works, drawn together under the title *Soliloquy*. In Thomas Demand's case, the equally conscious and careful composition of his large-format photographs is based on the artist's sculptural works. He prepares his spaces – often resorting to the use of historically significant places – as models out of paper and cardboard, in order then to photograph them.

In a different way the photographs of Hiroshi Sugimoto evoke a feeling of insecurity in the spectator in relation to the question of the degree of reality of what is actually seen. The Japanese artist chooses as the theme of his black and white photographs famous architectural sites – buildings or places – whose appearance, because of the multiplicity of pictures of them, always from the same accustomed, traditional perspectives, seems eternally fixed. Sugimoto does not transform this view in the direct sense of the word. He chooses an unusual standpoint for the spectator and a technical procedure that together make the buildings that he photographs become blurred to the point of being unrecognisable, while at the same time bringing out their inner, essential being – their aura, their ambience and their presence.

In contrast to this, in Andreas Gursky's photographs reality works on the spectator with a directness that makes them appear unreal. The imaginary monumentality that the photograph *Rhine II* exudes is due not least to the stark composition of the picture. And yet Gursky's work too is attributable to a tradition of factual-documentary photography. Along with Candida Höfer, Thomas Ruff and Thomas Struth, he belongs to the group of photographers who are strongly influenced by the work of Bernd and Hilla Becher.

The series of photographs of 1988–2001 by Bernd and Hilla Becher, *Shingle and Gravel Works*, is one of the important acquisitions of the Siemens Arts Programme. The photographs, which record the various manifestations of a type of building that is always the same, each time from the same perspective and before a neutral background, assemble into a typology that calls on the spectator to view them comparatively.

The art of the video offers, more than the photograph, the technical conditions by means of which the artist can extend the precise perception of reality, manipulate it, or even create artificial new realities, in which the accustomed human spatial and temporal dimensions are replaced by other, virtual concepts.

Bill Viola's *Tiny Deaths* suggests a dimension that lies outside our experience of reality by means of a recording of a photographic shot that slowly develops and then, on reaching the point of the most intense light, suddenly disappears.

In contrast, Rineke Dijkstra, whose work *The Buzzclub* is among the most recent acquisitions of the Friends of the Pinakothek der Moderne, concentrates on exact observation. She fixes her camera on one or two adolescents who are moving in time to music. The unwavering eye of the camera hones the spectator's feeling for the inner tension of the young people, who balance their behaviour between a self-staged performance determined by outside influences and their own personalities.

Francis Alys's video of his provocative walk, openly armed, through Mexico City (*Re-Enactment*) also experiences a duplication through its replaying. But it is not a case here of the same film – and this difference remains scarcely perceptible to the spectator – but of two versions of the same events. First the actual action is played back; in the second case it is re-enacted and filmed by the artist with the same characters.

The effect of Bruce Nauman's video installation *World Peace (Projected)* also relies on a repetition, but this time on a spoken level. The spectator is confronted with various large 'portraits'. The subjects of the portraits repeat a litany of the same phrases over and over, suggesting to the spectator in their midst that he is taking part in a process of communication, but it is one that cannot be understood nor does it have any exchange or result.

Bruce Nauman's enactment of an exhortation to peace, albeit deeply sceptical, finds no basis in the video work of Johan Grimonprez. His video, which takes as its theme advertising, documentation and sequences of feature films, is presented as a lively collage in which music and text are integrated. Starting with the history of aeroplane hijacks, which is paralleled with the history of how they were reported in the media, Grimonprez presents a fiction that appears all the more real because the film material used in the video is actual footage.

Finally, the elements from which Pippilotti Rist has created *Himalaya Goldstein's Room* are equally heterogeneous and complex. In the apartment-like home the spectator feels protected but at the same time disturbed. A warm atmosphere evoked through light and colour contrasts with a sense of absence of place, which is summoned up through the accumulation of both everyday and bizarre furniture and objects, as well as the projection of various video films onto the furniture and walls. The boundary between interior and exterior becomes blurred: the feeling of security gives way to that of threat, the sense of identity gives way to a complexity that has its origin in the flood of contradictory images.

Francis Alys
Antwerp, 1959

Re-Enactment, 2000–01
Video on DVD, double
projection with sound, 5 min,
edition no. 1/4
(Inventory no. GV 133)
On loan since 2002 courtesy of
PIN, the Friends of the
Pinakothek der Moderne

Francis Alys has apparently
identical film sequences playing
next to one another on two
projection screens. They each
show the artist walking through
Mexico City openly carrying a
firearm and then eventually
being overpowered by the

police. While one of the films
shows the actual process of
events, the other is fiction – the
same action re-enacted with the
same characters. Where is the
difference? Do the films offer
the spectator the possibility of
judging the true content of
what they are looking at? Do
they allow him the chance to
gain distance, in order to view
and evaluate what he sees
analytically? Or is he helpless at
the mercy of a manipulation of
all his senses?

John Baldessari
National City 1931

Man Running / Men Carrying Box,
1988–90
Silver gelatine prints, vinyl
colour and oil paint highlights,
122.4 x 268 cm
(Inventory nos SAP 26/1–2)
Acquired 1997/1998

John Baldessari's work is
composed of various elements
that consciously transcend the
domain of photography. The
artist combines writing and
picture, photograph and
painting, illusion and abstraction
in such a way that the spectator,
who participates with a certain
perception in mind, is confused.
At the same time Baldessari uses
pictures steeped in symbolism, as
in the two-part work *Man
Running / Men Carrying Box*. The
right-hand half of the picture, in
yellow tones, shows the black
silhouettes of several men who
are carrying a black wooden
box, which reminds us of a
coffin; the running man in the
left-hand half of the picture
appears to be fleeing from the
'coffin'. His face is concealed by
a blue spot stuck onto the black
and white photograph, which
emphasises not only the different
colour schemes of the two
pictures (the complementary
contrast of the blue and the
yellow), but it gives the running
man anonymity, and thus lends
the statement made by the
picture the appearance of
universal validity.

Bernd and Hilla Becher
Siegen 1931 and Potsdam 1934

*Shingle and Gravel Works, South
Germany*, 1988–2001
Silver gelatine prints mounted
on cardboard, each picture
40.5 x 31.5 cm
(Inventory nos SAP 30/1–15)
Acquired 1997/1998

The series of portraits *Gravel and
Ballast Works* corresponds in its
conception and presentation to a
particular procedure of these
two photographers that has
characterised their work for fifty
years. Each of their themes,
which are taken from the world
of industrial architecture, is shot
from a slightly raised perspective,
isolated and against a neutral
background, so that we are
presented with a series of
photographs of the same format
which demand to be inspected
and compared because of their
close sequential ordering. These
black and white photographs are
more than an archive; they also
have an effect on a formal–
abstract level, and are perceived
as independent variants of
countless similar plastic shapes,
which, precisely because of their
strict arrangement and similar
handling, can be seen as individual
forms of a basic structure.

Thomas Demand
Munich 1964

Open Field, 1994
C-print, 183 x 270 cm
(Inventory no. KM 1070)
Acquired 1994

Thomas Demand's photographs
are unsettling in two ways: their
themes appear unreal or
artificial, but they can at the
same time be identified as
elements of the reality that
surrounds us and which is
familiar to us. The significance of
Thomas Demand's work lies in
the barely discernible difference
between the world and reality as
staged by the artist and the
manner in which they are
traditionally photographed. In
order to add a further facet to
the complex relationship
between theme, picture and
reality, Demand includes another
impulse to his pictures by
photographing sites of historical
significance.

Rineke Dijkstra
Sittard, The Netherlands 1959

*The Buzzclub, Liverpool,
UK/Mysteryworld, Zaandam, The
Netherlands*, 1996–97
Double projection of two
videos, 26 min 40 sec,
edition no. 5/8
(Inventory no. GV 125)
On loan since 2000 courtesy of
PIN, the Friends of the
Pinakothek der Moderne

It is not only the interface
between individually
conditioned and socially
prescribed modes of behaviour
that provides the focus for
Rineke Dijkstra's photographs.
Her photographs of adolescents

who are passing through the
process of self-discovery from
childhood to adulthood throw
up the question of the
possibility of identity in a
consumer-oriented and media-
driven society – a problem that
stands at the centre of her
artistic work. Rineke Dijkstra's
video of 1996–97, in which
teenagers simulate their
behaviour on the dance floor in
front of her camera, also conveys
the inner tension that arises
from their need to present
themselves in the right way and
their simultaneous desire to
strike an inner balance.

Peter Fischli and David Weiss
Zürich 1952 and Zürich 1946

Projection 2 (S) (Flowers), 1998
162 colour slides, 2 projectors,
programmed apparatus for
control of fade-in/fade-out
effect and focusing,
edition no. 2/4

(Inventory no. GV 116)
On loan since 2000 courtesy of
PIN, the Friends of the
Pinakothek der Moderne.

The projection *Flowers* shows
slides of blossoms which appear
close up and in minute detail on
the screen. In the prescribed,
timed sequence the pictures

appear across one another,
become blurred, in order to
allow the images that follow to
develop again to complete
focus. The pictures are
fascinatingly beautiful and
convey a dream-like impression,
for while they are effective as
real 'garden snapshots', their
intensity and technically

directed time sequence and
transformation allow them to
withdraw from the spectator's
conscious, individually decided
gaze – like dream pictures
coming from 'another' reality.

Johan Grimonprez
Trinidad 1965

Dial H-I-S-T-O-R-Y, 1997
Video on DVD, 68 min, edition
no. 14/35, artist's proof no. 7,
music and samples by David
Shea, text extracts from 'White
Noise' and 'Mao II' by
Don De Lillo
(Inventory no. GV 129)
On loan since 2001 courtesy of
PIN, the Friends of the
Pinakothek der Moderne

Johan Grimonprez's video
presents itself as a complex
collage, the materials of the
work deriving from various
contexts – the music by David
Shea and quotations from the
works of Don De Lillo combine
to make a film that throws light
on the way that history today is
manipulated, not only in the
arena of historical events, but
also in the attempt to control
them. Grimonprez brings
together in his film picture
material from the history of
plane hijacks, and from the
world of politics and
advertising, and out of this
develop lines of action, shock
factors, and connecting concepts
that permit the spectator no
distance, forcing him
emotionally and intellectually to
engage in this 'post-modern'
approach to history.

Andreas Gursky
Leipzig 1955

Rhine II, 1999
C-print, 207 x 357 cm,
edition no. 4/6
(Inventory no. GV 127)
On loan since 2001 courtesy of
PIN, the Friends of the
Pinakothek der Moderne

Andreas Gursky's monumental photograph *Rhine II* exudes peace and harmony. It is composed of different broad horizontal bands of colour, which cover the lower half of the picture, while the upper part of the photograph is filled with the homogeneous grey of the sky. Separated from the river by just a narrow band of grass, it appears to reflect the surface of the river, gently shimmering and covered in small waves. *Rhine II* is not the only instance where Gursky's factual–documentary approach – the apparently objective, static gaze with which he shoots the subjects of his photographs – leads to a suggestive effect. Lying somewhere between a Romantic vision of Nature and simply applied areas of colour, the photograph obtains its specific aesthetic from the difference between an illusory precision and imagination transported by the ambience that the image evokes.

Roni Horn
New York 1955

PI, 1998
A photographic work in 45
parts, 22 parts each 56 x 73.7
cm, 13 parts each 56 x 56 cm,
and 10 parts each 56 x 45.7 cm,
edition no. 1/5, Iris printed
photographs/Somerset Satin
paper
(Inventory no. 15537)
Acquired 1999

Roni Horn's sequence of
pictures of Iceland could be
described as an attempt to fix in
photographs the essence, not of
a personality, but of a landscape,
in which *PI*, the title of the
picture, consists of 45 different
shots. The artist approaches the
landscape from numerous visual
angles – its many 'faces', its
atmosphere, its virginity, and its
'collision' with civilisation and
culture. In this process she

herself, in her subjective role as
the author of the photographs,
appears almost to vanish, making
way for the spectator, who
surrenders to the rhythm of the
pictures – hung in a specific
order around the room – to
their intensity, to their
fluctuations in style, to their
strangeness and to their
proximity.

Teresa Hubbard and Alexander Birchler
Dublin 1965 and Baden,
Switzerland 1962

Eight, 2001
Video with sound, 3 min 35
sec, looped, edition no. 8/10
(Inventory no. GV 132)
On loan since 2002 courtesy of
PIN, the Friends of the
Pinakothek der Moderne

A scene at once disturbing,
moving and secret is repeated in
a loop on this video: a little girl
dressed for her birthday looks
through the window into the
night-time garden and then runs
outside in the rain to cut herself
a slice of the chocolate cake that
sits on the flooded garden table.
The next scene shows the child
dry once more in the shelter of
the house. Voices, colours and
atmospherically charged spaces

are concentrated into a
repeatedly broken, simple set of
actions that calls on memory,
emotion and the unconscious.
Teresa Hubbard and Alexander
Birchler return to techniques
and themes from film and art
history for their videos, and
'prime' their reflection on the
situations they study – situations
about memory, about temporal
and sensual perception – by
using elements of our collective
image-memory.

Bruce Nauman
Fort Wayne, Indiana 1941

World Peace (Projected), 1996
Five-part video installation
(Inventory no. B 884)
Acquired 1997

Bruce Nauman's work about
World Peace (Projected) focuses on
functioning communication as a
prerequisite for world peace. Five
of the total of seven actors who
gaze into the room from the
various large projection screens
speak the following sequence of
phrases insistently and
concentratedly: 'I'll talk – You'll
listen, You'll talk – I'll listen, I'll
talk – They'll listen.' This
murmured litany, the jumble of
voices with speech coming from
all sides, challenges the spectator's
powers of concentration. He can
experience sensually the
difficulty and complexity of a
sympathetic and successful
communication.

Shirin Neshat
Qazvin, Iran 1957

Possessed, 2001
Video installation,
9 min 30 sec, edition no. 4/6
(Inventory no. B 898)
Acquired 2001

The films of Shirin Neshat take
as their theme the division of
roles in Islamic society, and
contrast it with the emergence
of the individual from a strictly
regimented lifestyle, subjected to
religious regulations. The artist,
who was born in Iran in 1957,
dedicates herself in her lyrical
and at times enigmatic films to a
theme that deeply affects her
personally; it perhaps calls out
for consideration all the more
powerfully because Shirin
Neshat, who today lives in New
York, left her own country a
long time ago. Her films reflect
both a distanced, analytical view

and a feeling of the deep
identity crisis that grips the
woman in Islamic society when
she comes face to face with
Western civilisation.

Pipilotti Rist
Rheintal, Switzerland 1962

*Himalaya Goldstein's Room
(Remake of the Weekend),*
1998–99
Room installation in several
parts with videos, music by
Anders Guggisberg
(Inventory no. GV 110)

On loan since 1999 courtesy of
PIN, the Friends of the
Pinakothek der Moderne

Himalaya Goldstein's Room
reflects, as both a comfortable
and disturbing whole, the span
of a conglomerate of concepts
that is already established in the
title of the installation: an

enormous quantity of pieces of
furniture, large and small, useful
and decorative objects, fill a
room whose dim light is pierced
by various videos that are
projected onto furniture, sofas
or simply into the empty air.
The submission of every
component part to a normal
ambience is only an illusion.

The person entering the room
only slowly becomes aware of
the subtle breaks in the style.
Gradually he slips into the role
of the distanced spectator who
must discard the absurdity of the
familiar and the bizarre
explanation of the obvious.

Thomas Steffl
Munich 1970

Model Homburg, 2000
Film sculpture: hatbox, video
projector, projection screen,
edition no. 1/3, artist's proof no. 1
(Inventory no. GV 128)
On loan since 2000 courtesy of
PIN, the Friends of the
Pinakothek der Moderne

Thomas Steffl's work moves
around the boundaries of our
perception, around the
restrictions to which we submit,
not because we are lacking in

any physical capacity, but much
more on account of our mental
and emotional knowledge. In
the case of *Model Homburg* the
work lets us read the picture
projected onto the screen as a
Romantic landscape, as an
endless road, limited only by
the horizon along which we
glide soundlessly forward. In
fact the image is created in a
hat box. The brim of the hat,
shot with a small camera,
appears – magnified and blurred
– on the large screen as a path
into the unknown.

Hiroshi Sugimoto
Tokyo 1948

World Trade Center,
Minoru Yamazaki, 1997
Silver gelatine prints,
61 x 50.8 cm,
edition no. 10/25
(Inventory no. 15542)
Acquired 1999

Sugimoto's photographs of
famous examples of architecture
consciously dispense with the
known, representative views of
these buildings. They assume,
rather, an unusual viewpoint and
apprehend the architecture as a
picture constituted of light and
shadow in whose genesis we
have a part through the process
of looking at it. Thus it is
neither the characteristic
structure nor the prominent
silhouette that becomes the
central concern of the artist; he
tries to capture the atmosphere
of a building in a shadowy,
almost transparent image of it.

Sam Taylor-Wood
London 1967

Soliloquy III, 1998
C-type colour print,
227 x 257 cm,
edition no. 3/6
(Inventory no. GV113)
On loan since 1999, courtesy of
PIN, the Friends of the
Pinakothek der Moderne

The protagonists of the series
Soliloquy appear to be sleeping,
dreaming, lost in thought. The
large-format photographs for
this work were partially inspired
by important works in the
history of European painting. To
create a head and shoulders
portrait of a man or a woman, a
sequence of pictures is always
assembled as fixed, narrow bands
below the large motif. The

sequence serves at the same
time as an inner monologue
('soliloquy'), which describes
the dreams, thoughts, wishes and
erotic fantasies of the subject.
This domain, which normally
eludes capture on camera, is
characterised in the picture by
expanded, gently distorted
perspectives, so that a fluid,
unreal impression results.

Bill Viola
New York 1951

Tiny Deaths, 1993
Video/sound installation, three channels with black and white videos, channel three strengthened monotone, edition no. 2/2
(Inventory no. GV 109)
On loan since 1999 courtesy of PIN, the Friends of the Pinakothek der Moderne

Bill Viola's video works make use of the temporal dimension of this medium in order to release the perception of time from the context in which it is normally understood. Temporal processes are extremely decelerated, subjected to a strict rhythm, or are made conscious of the span of a lifetime within their infinity. So, while a shadowy form only acquires an unclear structure in this video, and dissolves in the moment of the greatest brightness like an explosion, *Tiny Deaths* also appears to indicate – together with other questions of psychological perception – the limited nature of human existence before the infinity of cosmic time.

Jeff Wall
Vancouver 1946

Eviction Struggle, 1988
Large diapositive in a light box, 249 x 434 cm
(Inventory no. 15319)
Acquired in 1992 with the help of the Siemens Arts Programme

At first sight the scenes photographed by Jeff Wall have a banal and humdrum effect. Even the suburban landscape, which provides the frame of the central action of *Eviction Struggle*, suggests normality, as long as our gaze does not fall upon the people fighting with one another in the front garden of one of the middle-class houses lined up one next to the other. One family is being driven from their house with the help of the police; this is not presented as *fait divers* by the artist – rather Jeff Wall presents the social drama in the sense of a classical historical picture. Stances and gestures, the careful positioning of the principal players and of the spectators can be traced to compositions by David or Poussin, so that the ordinary scene is raised to the level of one of universal human significance.

Jeff Wall
Vancouver 1946

A Villager from Aricaköyu arriving in Mahmutbey, Istanbul, September 1997
Large diapositive in a light box, 227 x 289 cm, edition no. 2
(Inventory no. 15503)
Acquired 1998

If light plays a special role in general in Jeff Wall's photographs – not only through light boxes, which the artist uses to present his photographs – then in this picture of strangers arriving in an Istanbul suburb it acquires an almost impressionistic quality.

Against the background of a milky white sky the delicate lines of provisionally installed electric power lines criss-cross; in the background regularly-shaped pastel-coloured blocks of housing stretch far out into the plain – two minarets are the only things that rise up higher. The delicate shades of colour of the photograph remove the picture from crude reality. The conscious evocation of the memory of Impressionist landscape painting directs our attention to the careful composition of the picture, in which nothing is left to chance.

Index

Alys, Francis 114
André, Carl 92
Appel, Karel 73

Bacon, Francis 66
Baldessari, John 114–115
Balkenhol, Stephan 105
Baselitz, Georg 97–98
Baumeister, Willi 70
Becher, Bernd and Hilla 117
Beckmann, Max 42, 62–64
Beuys, Joseph 106–108
Birchler, Alexander 122
Boccioni, Umberto 20
Braque, Georges 15, 17
Burri, Alberto 87

Chamberlain, John 97
Chillida, Eduardo 81
Chirico, Giorgio de 45
Corinth, Lovis 35
Cragg, Tony 106

Dalí, Salvador 48
Delaunay, Robert 19
Demand, Thomas 117
Dijkstra, Rineke 118
Dix, Otto 44

Ernst, Max 46–47

Feininger, Lyonel 53
Fischli, Peter 118
Flavin, Dan 94
Fontana, Lucio 86
Freundlich, Otto 52

Geiger, Rupprecht 71
Grimonprez, Johan 119
Gris, Juan 19
Gursky, Andreas 120–121

Heckel, Erich 26
Hofer, Karl 45
Horn, Roni 122
Hubbard, Teresa 122

Immendorff, Jörg 100

Jawlensky, Alexej von 15
Johns, Jasper 76–77
Jorn, Asger 71, 73
Judd, Donald 95

Kandinsky, Wassily 21–22
Kiefer, Anselm 99
Kirchner, Ernst Ludwig 26,
 28–31
Kirkeby, Per 80
Klee, Paul 54–55, 57
Kline, Franz 74
Knoebel, Imi 109
Kokoschka, Oskar 35
Kooning, Willem de 74
Kounellis, Jannis 87

Léger, Fernand 18
Lehmbruck, Wilhelm 34
Lüpertz, Markus 98

Macke, August 22
Magritte, René 48
Marc, Franz 22, 24–25

Marini, Marino 65
Matisse, Henri 17
Meidner, Ludwig 34
Miró, Joan 50
Modersohn-Becker, Paula 25
Moholy-Nagy, László 57
Moore, Henry 65
Morris, Robert 95
Motherwell, Robert 73
Müller, Otto 33

Nauman, Bruce 123
Nay, Ernst Wilhelm 70
Neshat, Shirin 123
Nitsch, Hermann 88
Nolde, Emil 33

Palermo, Blinky 89–90
Penck, A. R. 100
Picasso, Pablo 14–15, 40–41,
 50–51, 64
Polke, Sigmar 101, 103
Prem, Heimrad 68

Rainer, Arnulf 109
Rauschenberg, Robert 75
Richter, Gerhard 103–105
Rist, Pipilotti 124

Saura, Antonio 66
Schlemmer, Oskar 52
Schmidt-Rottluff, Karl 31, 44
Schumacher, Emil 80
Segal, George 90
Serra, Richard 93
Severini, Gino 20

Steffl, Thomas 124
Sugimoto, Hiroshi 125

Tàpies, Antoni 77
Taylor-Wood, Sam 126
Twombly, Cy 79

Vedova, Emilio 77
Viola, Bill 127

Wall, Jeff 127
Warhol, Andy 91–92
Weiss, David 118
Winter, Fritz 68
Wols 68